BASEBALL
IN
KENNESAW

BASEBALL
IN
KENNESAW

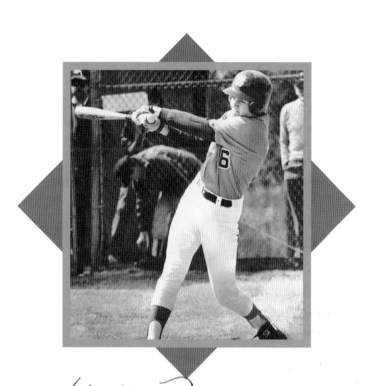

Shannon Caudill and Joe Bozeman
Foreword by Harvey Cochran

ARCADIA
PUBLISHING

Published by Arcadia Publishing
Charleston, South Carolina

Printed in the United States of America

Library of Congress Control Number: 2020939815

For all general information, please contact Arcadia Publishing:
Telephone 843-853-2070
Fax 843-853-0044
E-mail sales@arcadiapublishing.com
For customer service and orders:
Toll-Free 1-888-313-2665

Visit us on the Internet at www.arcadiapublishing.com

To our dads—who gave us the gift of love for this game.

To the Kennesaw players, coaches, parents, and families who know the joy of baseball.

To the Kennesaw-area players who were impacted by the 2020 coronavirus pandemic, which shut down the sport for the spring season—some of you were on the verge of making it big, all were kept from your special moments on the field, and many 12-year-olds who had worked so hard were denied your once-in-a-lifetime trip to Cooperstown for the annual tournament . . . we pay tribute to you all and look forward to your next opportunity to "Play Ball!"

CONTENTS

FOREWORD

I had the privilege of becoming the head baseball coach at North Cobb High School in 1971 and held that position for 35 years. In our early days, the young men who made our program so competitive came from Kennesaw's Adams Park, Acworth, and Preacher Clackum's Lost Mountain program. There were no travel baseball programs; rather, the local parks and recreation programs became responsible for teaching these young men to pitch, hit, catch, and compete. I am pleased that this book pays tribute to Preacher Clackum, a man who dedicated his life to building baseball in this area and provided the first Little League program in the Kennesaw area. Preacher made a lot of memories for baseball players on his hand-built fields, our own community's version of the *Field of Dreams* story.

Kennesaw's Adams Park has proven itself an exceptional and sustained baseball program thanks to the volunteer coaches whose extraordinary efforts allowed these children to grow into gifted athletes and exceptional young men who would later coach children of their own. My grandson Alec played at Adams Park in Kennesaw, and I truly loved watching him and his teammates learn and play the game the right way. The excitement in their eyes foretold what for many would become a journey toward excellence and a commitment to chase a dream of playing high school, college, and professional baseball. I am very pleased that the authors behind this book are donating all their royalties to the Kennesaw Baseball and Softball Association to benefit the youth players at Adams Park. As a community, we should do all we can to ensure baseball continues to resonate with our youth.

Today, local high school baseball has expanded to include Kennesaw Mountain, Hillgrove, Harrison, and Allatoona High Schools as well as Mount Paran and North Cobb Christian Schools, all of which have established top-notch programs. Kennesaw State University has built a nationally recognized program at the Division I level. Businesses have grown in our area to provide coaching services and facilities for the growing baseball talent. The Atlanta Braves moved their stadium north of Atlanta to be closer to the baseball culture and fans north of the city. In short, Kennesaw is now a recognized destination in the baseball world.

The very nature of the game of baseball requires an inherent passion and attention to detail that no other sport demands. I have found that the very best athletes who played for me were also the most intelligent and received excellent fundamental training at a young age. Kennesaw and the surrounding area produce great baseball players. This book tells the story of many who have gone on to play at the high school, college, and major-league levels. Regardless of the final destination, every kid who picks up a baseball, even for a short while, is better for it and is bonded to the sport in a special way for the rest of his or her life. The pages in this book help tell that story and remind us of our collective baseball journey.

—Harvey Cochran
Executive Director, Georgia Dugout Club

ACKNOWLEDGMENTS

With the assistance and support of the Kennesaw Historical Society, Kennesaw State University Archives, and the Southern Museum of Civil War and Locomotive History, the authors hope to shine a bright light on the strong connection of baseball to Kennesaw history, its people, and the region. Special thanks go to JoyEllen Williams, special collections curator of museums, archives, and rare books at the Kennesaw State University Archives, and Lewis Bramlett, president of the Kennesaw Historical Society. We would like to thank Doug Rhodes, former president of the Kennesaw Baseball Association at Adams Park, for his support and encouragement for this project early on. Many thanks to Irene Clackum and the Clackum family for their generosity in sharing photographs and stories about Eugene "Preacher" Clackum and his son Danny, the field and league they created, and the Clackum family's support of baseball in this area. Thank you to all who contributed photographs and recollections to this piece of baseball history. We couldn't have done it without the support of our baseball community. We also want to express our appreciation to Arcadia Publishing and our editor Caroline Anderson for her guidance, support, and patience as we worked on this book. The authors are donating our royalties from this book to the Kennesaw Baseball and Softball Association at Adams Park. We believe strongly in sharing our love for the sport and supporting local youth baseball programs.

INTRODUCTION

The Kennesaw area is now ripe with baseball talent because of an illustrious history and baseball culture that dates to the late 1800s. A former rural community, Kennesaw has grown quickly, and baseball programs have flourished with a sea of young talent to support them. This book captures some of that lost history for the benefit of our community. Young players today can still pick up a bat or glove and imagine themselves on the fields of old, because there is a shared experience that stretches back generations. That is the power of this sport. It transcends generations with a magic touch, providing a dream of making it to the major leagues and giving the old the memory of the big hit, the game-saving catch, or the big win.

The inspiration for this book came from the coaches, parents, and players of the Kennesaw Baseball and Softball Association at Adams Park, where there was a lot of history passed on by word of mouth: "Dansby Swanson used to play here." "There used to be a ballfield called Clackum Field, but it doesn't exist anymore." "There was this amazing kid who later got drafted, but I can't remember his name." And so it goes. No one had taken the time to write much of this history down, whether for a book, a web page, or any other media outlet. The closest Kennesaw's baseball history has come to being documented is in five photographs in Joe Bozeman's coauthored Images of America: *Kennesaw* book. Thus, the starting point for this book was a partnership between the two authors, which built off of Bozeman's photographs and baseball recollections. The chapters of this book uncover a very rich and vibrant baseball history that is sure to inspire the next generation of players and bring back a flood of memories for former players, coaches, and parents alike.

Two figures loom large in the history of baseball in Kennesaw: Eugene "Preacher" Clackum and Harvey Cochran.

Preacher Clackum built the first ballfield in Kennesaw for youth players. He earned his nickname because he couldn't stop talking about baseball and coaching others on the sport. He was "preaching" about baseball nonstop. A former semipro player who played on teams in three Georgia counties in the 1930s and 1940s, his passion for the sport led him to build a baseball field on his own farmland in 1948. It was initially motivated by his desire to have a place near home to play baseball with adults and teenagers on the weekends. Later, he decided to convert it to a youth baseball field for the benefit of his son Danny and local kids. Even though there was often a bare cupboard because of Preacher's investment of his earnings in the field, his wife, Ethel, supported him every step of the way and played a central part in organizing the many supporting functions of a youth league, like concessions, fundraisers, and professional correspondence with newspapers and local officials. His youth baseball league lasted from 1952 until 1986. Fittingly, he died on Clackum Field's opening day in 1977, and his funeral was held on the field he so lovingly built with his own hands. Danny, who grew up playing on Clackum Field and would play minor-league baseball for the Boston Red Sox, took care of the field and league from 1977 to 1986. The decision to close the league and field was a heart-wrenching one, but he had the pressure of a fulltime job at Coca-Cola and failing knees from his many years as a catcher. There was also competition from other youth baseball programs like Adams Park. Clackum Field had

served its purpose and was later sold to Cobb County with the mutual agreement that the field would remain a space to benefit youth sports. Both parties agreed in the sales contract that it would become the softball field for Harrison High School, which opened in 1991. Today, the field still bears the name "Clackum Field" and can boast two high school state softball championships in 2000 and 2018. Clackum's legacy lives on.

Harvey Cochran spent 42 seasons coaching baseball at Brown High School, North Cobb High School (Kennesaw), North Atlanta High School, and Mount Paran Christian School (Kennesaw) before retiring in 2012 with a 682-348 career record. Coach Cochran spawned a generation of area coaches and players, including Kyle Reese, who coaches Mount Paran Christian School, and brothers George and Keith Hansen, who currently coach Kennesaw Mountain High School and Allatoona High School, respectively. His impact on the development of area baseball programs cannot be understated, and his name repeatedly came up as we interviewed coaches, players, and family members for this book. Even though he is retired from coaching, he continues to have a major impact on baseball in Georgia with his leadership as the executive director of the Georgia Dugout Club, which serves as the official Georgia Baseball Coaches Association, and as an advocate for high school and college-level baseball in the state. The organization publishes an annual *Georgia Dugout Preview* that highlights high school baseball talent across Georgia and baseball-related services.

As you turn these pages and learn these stories, reflect on the importance of this sport in the Kennesaw area, its role in developing youth athletes and leaders, its contribution to baseball competition and history, and the sheer talent that has matured at all levels of baseball play from this area. There is magic in the words "Play Ball!"

BIG SHANTY BALL

EARLY BASEBALL IN KENNESAW

The *Atlanta Constitution*'s first article about a Kennesaw baseball team was written in 1874 about a match between the Marietta Kennesaws and the Atlanta Castalias. At the time, the area that is now Kennesaw was known simply as Big Shanty, after the temporary structures (shanties) used by laborers while grading and constructing the railroad from 1838 to 1841. In 1887, the town of Kennesaw was officially incorporated, and a baseball team was soon organized. In June 1908, the *Constitution* ran a photograph with the caption "This is the Kennesaw team which is showing up well with the amateur bunches in the northern section of the state." According to Robert Jones's 2008 *Kennesaw in the 20th Century*, "In the early twenties, Kennesaw had a very good country ball club, managed by one Joe Gluck, and they played against all the neighboring communities—Dallas, Woodstock, Emerson and Hill's Park in Atlanta and even as far away as Copper Hill, Tennessee. The team was called 'The Kennesaw Smokers,' advertising a popular brand of cigars of those days." Since baseball's beginnings in Kennesaw, it has connected with the character of the people, allowing for a thriving, competitive baseball culture. The relationship with and love of the game that so many in this area share can be traced from these humble beginnings. It is because of them that the words "Play Ball!" have so much meaning here.

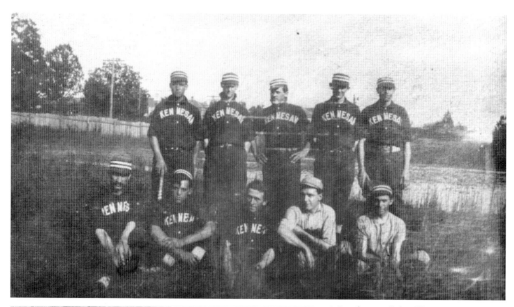

Members of the Kennesaw team pose for a photograph around 1900. A June 1908 edition of the *Atlanta Journal-Constitution* ran a story about the Kennesaw team and featured a photograph of the team wearing jerseys very similar to those seen in this photograph. (Courtesy of Lewis Bramlett.)

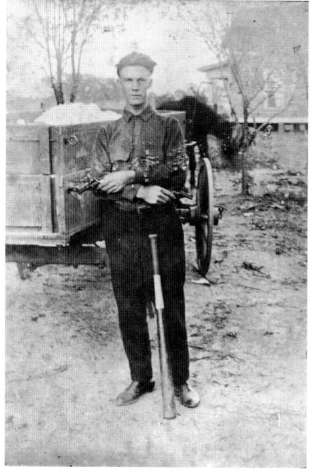

Johnny M. Brown played baseball for the Kennesaw team. In this c. 1919 photograph, he stands in front of a wagon loaded with cotton at his family home on Dallas Street. The Browns were cotton farmers, and Johnny was likely taking the wagon to the cotton gin for processing. He is pictured with his favorite handguns and baseball bat. (Courtesy of the Georgia State Archives.)

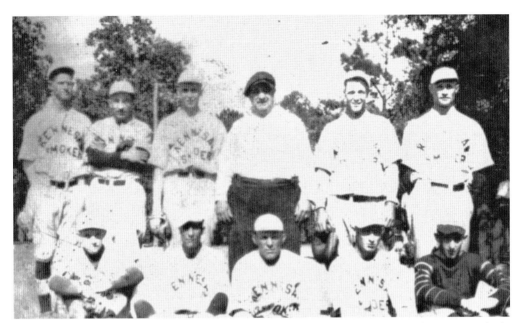

This 1922 photograph shows the Kennesaw Smokers, a semipro team. The manager was Joe Gluck, sometimes spelled Glueck (second row, center). Also pictured are Horace Adams, Mel Pendley, Morris Brooks, Hoy and Lloyd Cantrell, and Frank McCutcheon. The team was named after Kennesaw Smoker brand cigars, which were produced at the Marietta Cigar Factory in Marietta, Georgia. (Courtesy of Joe Bozeman.)

This 1930s photograph captures a baseball game being played in downtown Kennesaw. As Joe Bozeman recalls, left field ended near the depot, and the infield was where the food truck parking lot is now. (Courtesy of Joe Bozeman.)

Another 1930s photograph shows a game in progress at the former downtown Kennesaw ball park. (Courtesy of Joe Bozeman.)

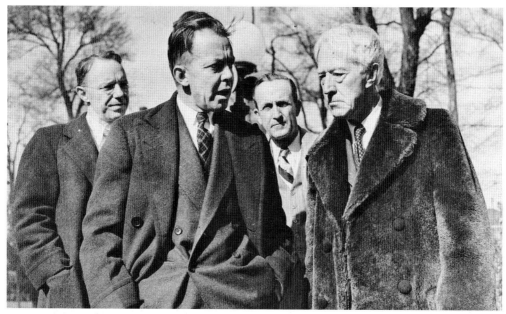

Kenesaw Mountain Landis was a federal judge who presided over the trial of eight members of the Chicago White Sox for conspiring to lose the 1919 World Series. He was selected as the first commissioner of baseball to clean up the sport's image and root out corruption. Landis's father was a Union soldier who was wounded at the Battle of Kennesaw Mountain and decided to name his son after the mountain as he lay in the Archibald Howell House, which had been converted into a field hospital. He misspelled the name by dropping an "n." In this 1930s photograph, Landis (right) and entourage tour the battlefield. With him are, from left to right, Atlanta mayor William Hartsfield, Marietta mayor L.M. Rip Blair, and Trammell Scott, president of the Southern Association Baseball League. (Courtesy of the Georgia State Archives.)

Kennesaw's semipro field was the only baseball field in the area in the early 1900s, so Kennesaw players would travel elsewhere to play. In this 1940 photograph, Kennesaw's Eugene "Preacher" Clackum poses with his Marietta City team. The story of Kennesaw's Clackum Field begins with Preacher Clackum's experience as a player for a variety of teams in Cobb, Cherokee, and Fulton Counties. From left to right are (first row) Harold Padgett, Hexchel Dorris, Doug Hunter, Bill Spinks, Dip Parker, Stanley Hunter, and Joe Bo Foster; (second row) Dick Hunter, Al Bishop, Paul Morris, Rube Roberson, Clackum, umpire Dizzy Dean, Alton Orr, and Elbert Rucker. (Courtesy of the Clackum family.)

The semipro Kennesaw Smokers, pictured around 1950, traveled to games throughout Georgia, occasionally playing as far away as Tennessee. For a list of the players' names, see the cover background caption opposite the title page of this book. (Courtesy of Joe Bozeman.)

In this 1950s photograph, Kennesaw children play baseball downtown in the area that is currently behind the State Farm insurance office on Main Street. City hall is in the background at right, and Stacy Davis's house is at far left. The children would gather here for impromptu games using the wooden chicken coop of Joe Bozeman's grandparents as the backstop. A young Joe Bozeman has his back to the camera in the outfield. (Courtesy of Joe Bozeman.)

This c. 1970 photograph captures the reunion of the 1920s Kennesaw Smokers. From left to right are Hoss Bozeman, Melvin Pendley, Clarence Gallagher, Bob Bozeman, Frank McCutcheon, and unidentified. (Courtesy of Joe Bozeman.)

BIG SHANTY BALL

Clackum Field, Kennesaw's "Field of Dreams"

1948–1986

Kennesaw could boast its own "Field of Dreams" when Eugene "Preacher" Clackum built his own baseball field, opened it to the public, and helped organize the Lost Mountain Little League. Clackum and other early players, coaches, and leaders left an indelible mark and rich baseball legacy in the Kennesaw area. Clackum designed his field for adult baseball, and from 1948 to 1952, the field was primarily used for scrimmages of adults and teenagers on weekends. In 1952, Clackum decided to revamp his field to meet the needs of young players, including his son Danny (60-foot base paths and a 40-foot pitcher's mound), and also added dimensions for Pony League (13- and 14-year-old boys), which required 75-foot base paths and a 54-foot mound. Thus Preacher's legacy in youth baseball was formed. Thousands of young players and their families passed through Clackum Field during its 38 years. Jim Nash learned to pitch there, signing his contract to play in the big leagues in a dugout at Clackum Field in 1966; he appeared on the cover of *Sports Illustrated* a year later. North Cobb and McEachern High Schools played at Clackum until the schools built fields of the same quality. North Cobb High School coach Harvey Cochran also umpired there to support the youth league (and scout talent). Braves shortstop Dansby Swanson can trace his family's baseball history to Clackum Field: his father, Cooter, learned baseball there, as did his great uncles Zeke and Raymond. Appropriately, Preacher passed away on opening day in 1977. His son Danny took over responsibility for maintaining the field for nine more years.

After the 1986 season, the Clackum family decided to sell the field to Cobb County with the stipulation that it remain a ballfield. For Danny Clackum, many factors led to the decision to sell: the stress and cost of maintaining the baseball park, deteriorating knees from many years of catching, competition from newer and growing youth baseball leagues like Adams Park, and the extra work after a fulltime job with Coca-Cola. Today, the legacy of Clackum Field lives on at Harrison High School, where the Lady Hoya softball team plays on the field that still carries the Clackum name.

A shirtless Preacher Clackum coaches his youth team in the hot Georgia sun in 1954. This was the year that Clackum's teams entered the Marietta Pony League. The league's 1956 yearbook states that Clackum's team "has been one of the top teams in the league ever since" entering in 1954, which reflects the fierce drive and competitiveness that Preacher instilled in his players. (Courtesy of the Clackum family.)

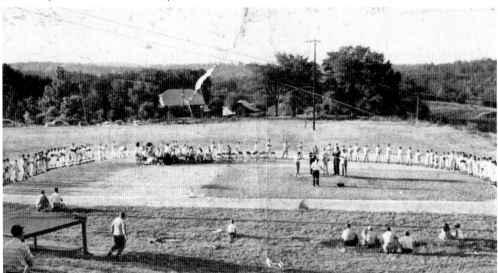

In this c. 1954 photograph, Preacher Clackum speaks near the pitching mound with local dignitaries as part of opening day ceremonies. At this point in the field's development, there were no bleachers for spectators, so families sat in the grass. Right fielders also had to contend with a pole in the field of play until it could be fenced off. (Courtesy of the Clackum family.)

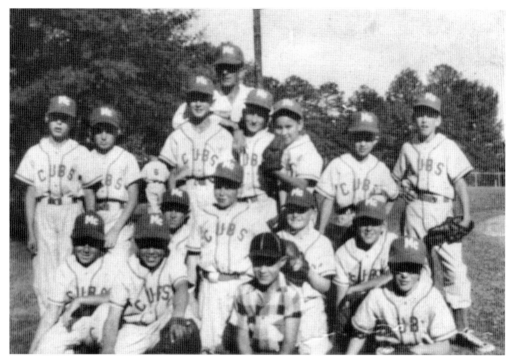

In this 1954 photograph, coach Preacher Clackum poses with his Clackum Field Cubs prior to a game. In addition to building, maintaining, and managing the Clackum Field facilities, Clackum also coached youth teams. (Courtesy of the Clackum family.)

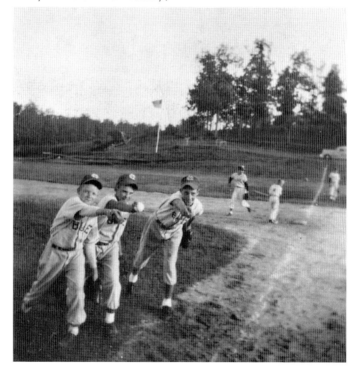

Clackum emphasized baseball fundamentals and sportsmanship. In this c. 1955 photograph, players practice and pose prior to a game at Clackum Field. (Courtesy of the Clackum family.)

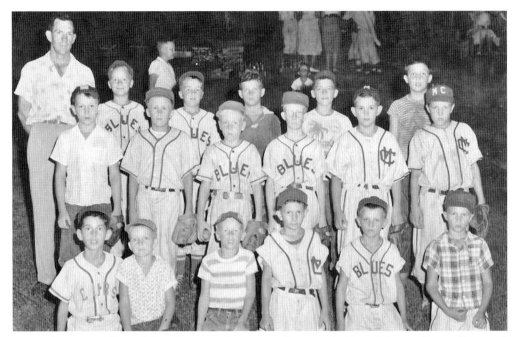

Around 1955, members of the Blues pose for a team photograph. From left to right are (first row) Gary Kinsey, Don Clark, Hall Walls, Jerry Baynes, Buddy Davenport, and Barry Smith; (second row) Bill Hedrich, Luther McConnel, Kerry Knight, Larry Farrell, Murl Hardy, and Alton Verhine; (third row) Coach Knight, Charles Turner, Terry Walls, David Whitmore, Don Womack, and James Self. (Courtesy of the Clackum family.)

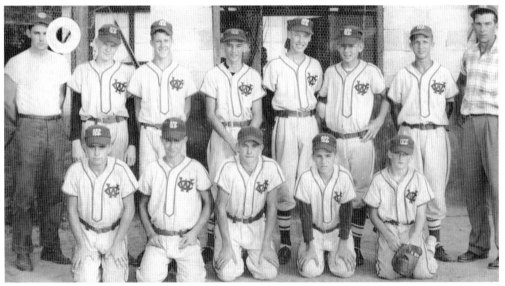

This c. 1955 photograph captures a team after receiving new uniforms. The logo is for West Cobb, as teams playing at Clackum went through a number of name changes. This team represented the West Cobb Baseball Association, which was the formal body that oversaw Clackum Field teams. (Courtesy of the Clackum family.)

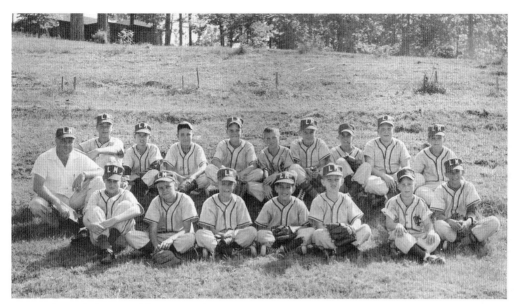

Pictured at Clackum Field in 1956, these Kennesaw players are wearing the jerseys of the Lost Mountain Baseball Association. From left to right in the first row are Ben Robertson, Joe Bozeman, Micky Bozeman, Jerry Weeks, Johnny Vansante, and Trooper Vansante. Coach Vansante is at far left. The second row includes Jack Weeks (without hat) and Bobby Bozeman. Joe Bozeman would later win the league's award for hitting the most home runs in a season. The City of Kennesaw later named its community center after Ben Robertson. (Courtesy of Joe Bozeman.)

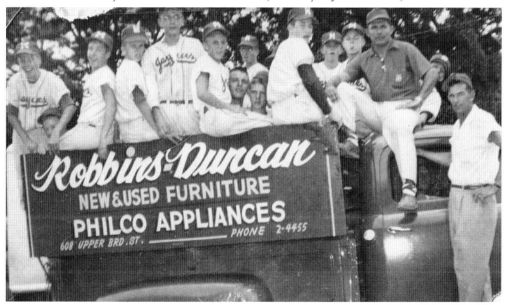

In this c. 1957 photograph, Clackum Field players are transported by truck for a game at a rival field. In the days before more strict safety laws, it was common to see a truckload of baseball players pull up to a field hauled by a coach or parent. In this case, a parent is using the truck from his own business. (Courtesy of the Clackum family.)

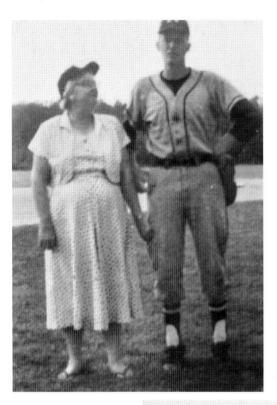

Ethel Clackum looks up at her 19-year-old son Danny at Clackum Field in this 1958 photograph. Preacher called Ethel his "right arm," because she oversaw concessions, barbeques, fundraising drives, and his official correspondence. Sportswriter Horace Crowe wrote a moving eulogy in the *Marietta Daily Journal* that said, "In this age of man-dominated sports administration, Ethel Clackum was one of the rare women of our time." (Courtesy of the Clackum family.)

Preacher Clackum poses with his son Danny at Clackum Field in 1958. Preacher and Danny would have regular one-on-one practice on Sundays called "drill time." Danny later played in the Boston Red Sox minor league system. (Courtesy of the Clackum family.)

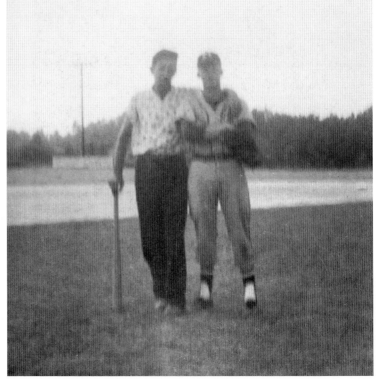

This August 1960 photograph captures some of the field improvements, like new backstop fencing and light poles. Preacher Clackum tried to make improvements to the field every year. Former big leaguer and Clackum Field alumnus Jim Nash remarked that Clackum Field's lighting was better than half the minor-league ballparks where he played. (Courtesy of the Clackum family.)

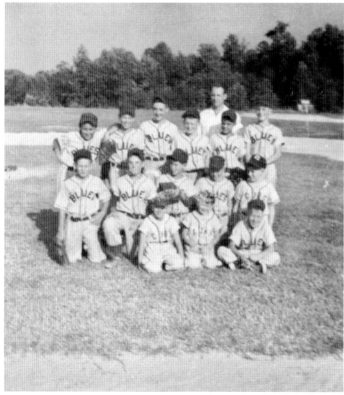

In this 1964 team photograph, the Blues pose at Clackum Field. Preacher Clackum built roofed bleachers for spectators on the west side of the field, dugouts, and a concession stand to accommodate the growing league. (Courtesy of the Clackum family.)

Members of the Blues practice how to handle a pickle situation in 1965. Photographs like these capture the pure joy that Preacher Clackum created from farmland. Thousands of players and families can trace their baseball roots to these fields. (Courtesy of the Clackum family.)

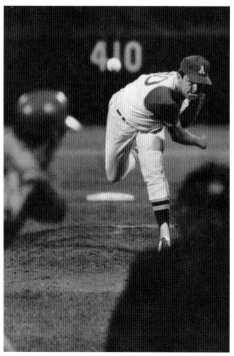

Jim Nash throws a strike in a September 7, 1966, game in his rookie season with the Kansas City Athletics. Nash got his start in baseball at Clackum Field before playing in the major leagues from 1966 to 1972 for the Tigers, Athletics, Phillies, and Braves. He debuted for Kansas City on July 3, 1966, against the Detroit Tigers after the Athletics signed him as a free agent. During his rookie season, he went 12-1 with a 2.06 earned run average in 127 innings pitched. He appeared on the cover of the March 13, 1967, *Sports Illustrated*. Nash credited Preacher Clackum with giving him the confidence to compete at the professional level by placing him in games against adult semipro and minor-league talent. Before Kansas City would sign him, the team asked for one last pitching display, which Nash completed at Clackum Field; he then signed the contract in a Clackum dugout. (Courtesy of the Nash family.)

This large group photograph was taken on opening day in May 1973. Preacher Clackum can be seen at center wearing a jacket and an LM (Lost Mountain) baseball hat. The field Clackum built was officially known as West Cobb Baseball Park, but sportswriter Horace Crowe observed in 1976 that it is "more affectionately known by hundreds as Preacher Field." (Courtesy of the Watkins family.)

A team poses at Clackum Field in 1972. From left to right are (first row) Doug Watkins, Dean Clackum, Kevin Porter, Johnny Prescott, unidentified, Chuck Carter, and Tim Welch; (second row) batboy Terry Kastner, Ronald Culver, Mike Kastner, three unidentified, Scott Hendricks, and coach Don Wilson. (Courtesy of the Watkins family.)

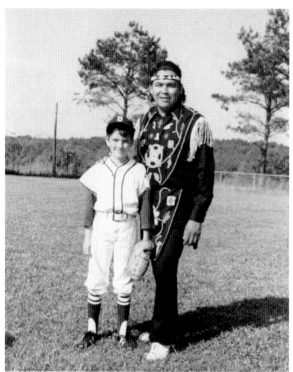

In this 1973 photograph at Clackum Field, Doug Watkins poses with Chief Noc-A-Homa, the mascot for the Atlanta Braves. His real name was Levi Walker. He approached the Braves in 1969 about having a real Native American portray the chief instead of white college students, and was hired. He served as the Braves' mascot until 1986, when they mutually agreed to end the relationship after disputes over pay and missed performances. (Courtesy of the Watkins family.)

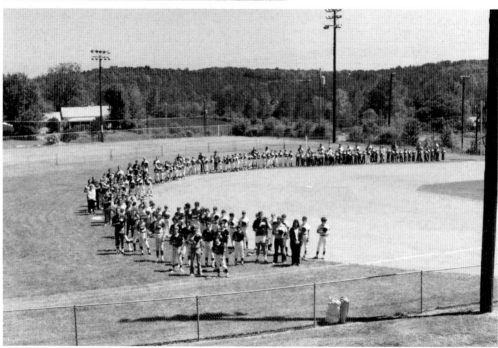

In this 1974 opening day photograph, players have removed their caps for the national anthem. The Lost Mountain Baseball Association stressed good sportsmanship and respect for baseball traditions. (Courtesy of the Clackum family.)

In this 1974 photograph, Preacher poses with his three grandchildren (from left to right) Shan Cook, Shane Cook, and Ronnie Clackum. The family made the uniforms especially for the children to wear on the 1974 opening day. (Courtesy of the Clackum family.)

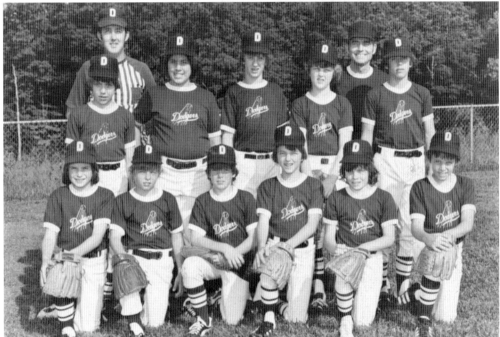

The Dodgers pose for a team photograph at Clackum Field during the 1974 season. From left to right are (first row) Doug Watkins, Dewitt Sosebee, Kevin Porter, Robert Hamilton, Johnny Prescott, and Scott Hendricks; (second row) Tony Sandoval, coach Mel Porter, Derrick Robinson, Mike Kastner, Jeb Schoonover, coach Lewis Watkins, and Chuck Carter. Coach Watkins served as the southeast commissioner for Pony, Colt, and Palomino baseball in the late 1970s. He was responsible for getting Palomino baseball started in Georgia. (Courtesy of the Watkins family.)

Preacher could often be found sitting or crouching around the diamond watching the games. In this 1975 photograph, he observes the action on the field. He suffered from several lung-related diseases and often had difficulty breathing in his later years. None of it would dissuade him from making his presence known at the field. (Courtesy of the Clackum family.)

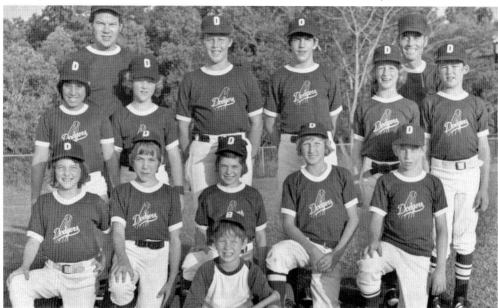

Around 1975, another Dodgers team poses for a group photograph at Clackum Field. From left to right are (first row) Kevin Porter, two unidentified, Doug Watkins, Dean Clackum, and unidentified; (second row) Dewitt Sosebee, coach Don Wilson, Tony Sandoval, Derrick Robinson, coach Lewis Watkins, and Carl Wynn. (Courtesy of the Watkins family.)

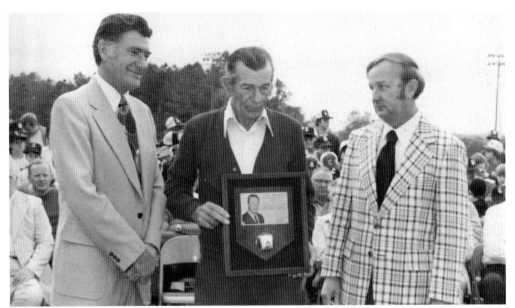

During the 1976 opening day ceremonies, the Cobb County Commission declared May 1 Preacher Clackum Day. In this photograph, Clackum receives the Joe E. Brown Fellowship Award from Little League Baseball (the highest award the organization gives), "in recognition and dedication to, and support of Boys Baseball, and the ideal of development of youth, through the medium of organized athletics." From left to right are Cobb County Commission chairman Ernest Barrett (for whom Barrett Parkway is named), Clackum, and Joe Townsend, a Little League Baseball official. Former teammates from the 1930s and 1940s were in attendance, as well as former major-league player Jim Nash. (Courtesy of the Clackum family.)

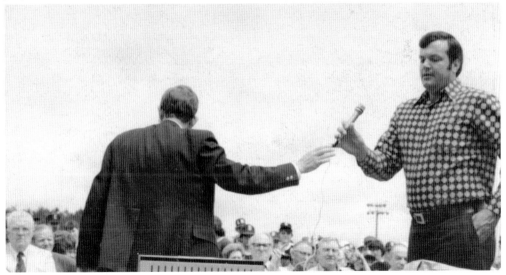

Jim Nash takes the microphone at the 1976 opening day tribute to Preacher Clackum. After Nash retired from professional baseball, he went on to be Kennesaw State College's first baseball coach in 1984 and led the team to a 30-20 record. (Courtesy of the Clackum family.)

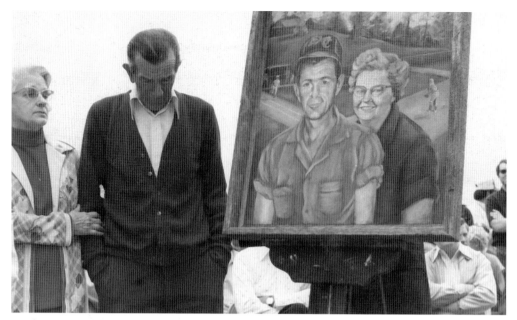

At the 1976 opening day tribute, Preacher Clackum was presented a painting of himself with his late wife, Ethel. In the background of the painting is the field they both so lovingly developed, financed, and supported. By all accounts, it was a truly emotional day for Preacher Clackum and his family. (Courtesy of the Clackum family.)

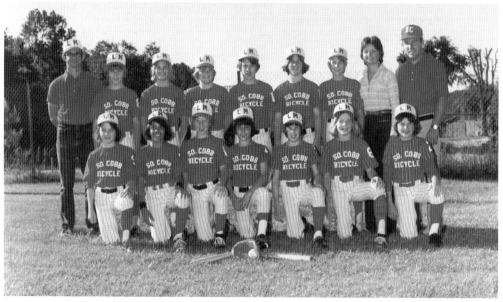

In 1976, the Lost Mountain South Cobb Bicycle team poses at Clackum Field. It was not uncommon for teams to be named after local businesses that sponsored them. From left to right are (first row) Doug Watkins, Jason Hough, two unidentified, Stan Fisher, Bill Melton, and Kevin Porter; (second row) coach Reginald Awtrey, Benny Hines, Jimmy Beasley, Keith Kendrick, Scott Brown, Wes Conley, Jeff Gilbert, team mom Betty Porter, and coach Bill Justice. (Courtesy of the Watkins family.)

On opening day, May 6, 1977, Eugene "Preacher" Clackum died. A few days later, his funeral was held on the baseball field he built with his own hands in front of a large crowd of family, friends, dignitaries, and current and former players. In this photograph, the hearse bearing Clackum's body prepares to depart from the field for his final resting place at Mountain View Park Cemetery in Marietta. His gravestone simply states, "He dedicated his life to youth baseball." A fitting tribute to a man who impacted the sport of baseball in this area. (Courtesy of the Clackum family.)

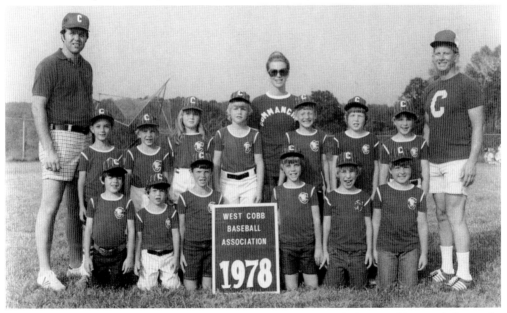

In this 1978 photograph, the West Cobb Commanches pose at Clackum Field. From left to right are (first row) Steven Shock, Darren Shock, Danny Leigh, unidentified, Jeff Rakestraw, and Eric Pugmire; (second row) coach Bo Gentry, Chris Harris, Calvin Cherry, Cindy DeLaney, Carter Gentry, coach Tish Gentry, Scott Garland, David Lawson, Kirk Underwood, and coach Noel Garland. (Courtesy of Cynthia DeLaney Gorman.)

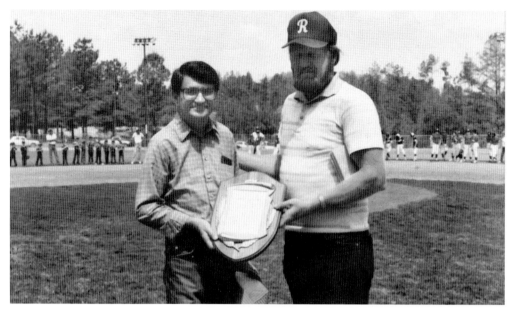

After the passing of Preacher Clackum, his son Danny took on a leading role in the care and organization of Clackum Field. In this c. 1982 photograph, Danny Clackum is honored by a local official for work in building the Clackum Field baseball program. He would later start to assemble photographs and hand-written notes for a book project intended to capture his father's and family's legacy that was tentatively titled *From Farm to Baseball: Growing up in West Cobb at Preacher Clackum Field*. Sadly, Danny passed away before he could publish the book. (Courtesy of the Clackum family.)

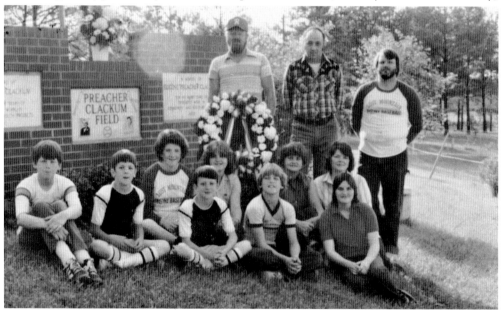

In this 1982 photograph, Danny Clackum (wearing hat, standing at left) places flowers in front of the brick and concrete "Preacher Clackum Field" sign that paid tribute to both of his parents. With Danny are members of the Lost Mountain Pony League team. (Courtesy of the Clackum family.)

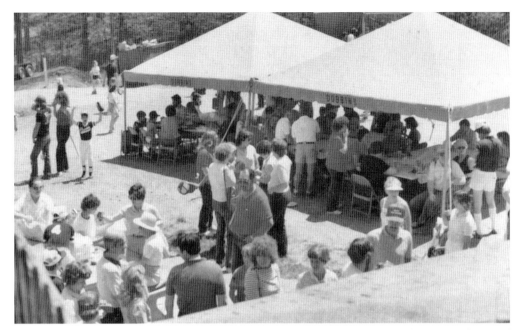

Clackum Field was known not only for its baseball but also for its many family get-togethers and barbeques. The baseball league was a social center for many in the community. In this June 1983 photograph, families gather near the concessions for barbeque and camaraderie. (Courtesy of the Clackum family.)

On opening day in 1983, the Clackum family gathered to honor supporters and leaders of the Lost Mountain Baseball Association. From left to right are Charles McFalls, Irene Clackum, Danny Clackum, Chesley Clackum, Kim Clackum, Theresa Cook, Tracy Clackum (dressed as clown), Johnny Clackum, Ronnie Clackum, Shan Cook, and Shane Cook. Irene Clackum contributed to this chapter to preserve the legacy of the Clackum family. (Courtesy of the Clackum family.)

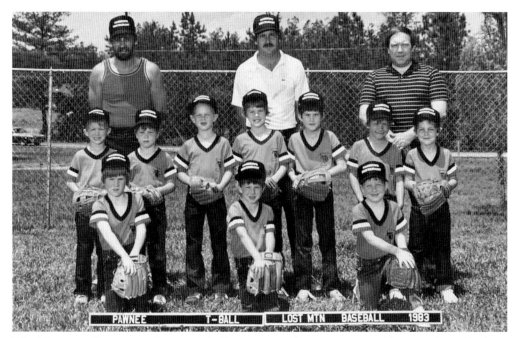

The Harrison's Restaurant Pawnee T-ball team poses for a 1983 group photograph at Clackum Field. At left in the second row is a young Adam Everett, who played at Clackum Field from 1983 until 1986 and then went on to play at Harrison High School. (Courtesy of the Everett family.)

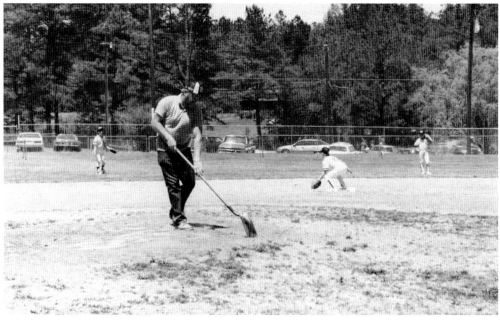

In this c. 1984 photograph, Danny Clackum prepares the field for a game while the Lost Mountain Athletics practice in the background. The Clackum family continued to take care of the field that bears their name after Preacher's passing, but no one bore that burden more than Danny. (Courtesy of the Clackum family.)

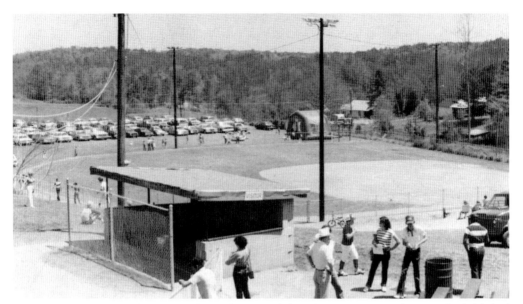

This photograph of Clackum Field shows the grounds between games around 1984. The fields had been expanded to two baseball diamonds as part of Preacher Clackum's continuous improvement efforts. (Courtesy of the Clackum family.)

Around 1985, Adam Everett prepares to bat at Clackum Field for the Crackers, which was the name of the old semipro Atlanta team that dissolved when the Braves moved from Milwaukee to Georgia in 1966. After graduating from Harrison High School, Everett went on to play college baseball for North Carolina State University and then the University of South Carolina. (Courtesy of the Everett family.)

1986 Lost Mountain Baseball Association

The 1986 Lost Mountain Baseball Association yearbook listed all of the teams, coaches, and sponsors for the season. It would prove to be the last yearbook and the final season for Clackum Field. Later in 1986, the Clackum family decided to end the association and close the field. The decision was difficult, but necessary. They later sold the property to Cobb County for use by Harrison High School, with the stipulation that the land would continue as a place for youth athletic development. (Courtesy of the Clackum family.)

Clackum Field still exists today as the softball field for Harrison High School. Preacher Clackum's legacy is not only traced to baseball but now to women's softball as well. On Clackum Field, the Lady Hoya team has won two state championships (2000, 2018) and eight regional championships (2002, 2004, 2005, 2009, 2010, 2011, 2014, and 2015). Preacher's legacy lives on. (Photograph by Shannon Caudill.)

3

ADAMS PARK AND THE KBSA

1959–PRESENT

In 1957, the City of Kennesaw began organizing a community recreation club, the forerunner of today's Kennesaw Parks and Recreation. In a July 4, 1957, community meeting at Kennesaw City Hall, civic leaders laid plans for a picnic area, playgrounds, and a clubhouse. These ideas led to the formation of Adams Park and eventually the Ben Robertson Community Center. In May 1959, Kennesaw opened a Little League for youth players, kicking it off with a 50-car parade through downtown Kennesaw. In the first league game, the Kennesaw Generals lost to the Kennesaw Blues 23-8 on May 5, 1959. In 1961, Kennesaw constructed a new baseball park for the league with lighting to allow for night games. On January 19, 1966, the city council voted to name the recreation area and its baseball fields Adams Park in honor of former mayor Johnny Adams. Adams Park has spawned many great high school, college, and professional players. Atlanta Braves shortstop Dansby Swanson refers to Kennesaw as his "old stomping grounds" because he got his start in baseball at Adams Park. What started as the Kennesaw Little League became the Kennesaw Baseball Association (KBA), and in 2019 was renamed the Kennesaw Baseball and Softball Association (KBSA) to include the robust softball program. Kennesaw and regional parents and children can enjoy the sport, make memories, and contribute to a long legacy of baseball in Adams Park. It is impossible to capture the history of every player, family, and team that graced the diamond at this park, but this chapter does its best to tell the story of Kennesaw's longest-serving youth baseball park.

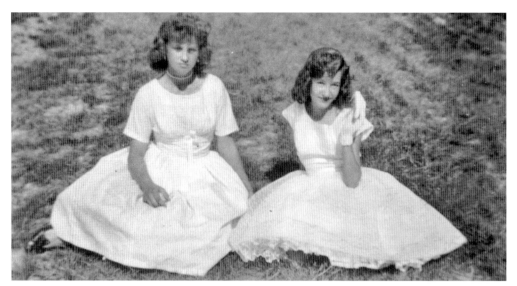

During the inaugural season of the Kennesaw Little League, organizers offered the opportunity for young ladies to participate in the festivities by hosting a Miss Kennesaw League beauty contest. In this photograph, Linda Bridges (right) was selected as Miss Kennesaw League over 16 other contestants on the league's first opening day in May 1959. Irene McGarity (left) was the runner-up. The photograph captures a time when women did not have equal access to sports. Today, it is not uncommon to see girls playing baseball or softball at Adams Park. (Courtesy of the Bridges family.)

Members of the 1967 Rebels, the Adams Park All-Stars, pose for a photograph. This team dominated the regional Little League tournament from 1963 to 1967 at each age group. From left to right are (first row) Terry Fields, Tony Carter, David Shelton, David Odom, Mike Green, Donny Rickman, and Butch Farley; (second row) Leslie Wells, Larry Long, Ronnie Krauss, Joe Cantrell, Morris Cantrell, head coach Ricky Bryant, Eddie Taylor, Ronnie Davenport, coach Taylor Maxwell, Larry Massey, and Jay Askew. (Courtesy of the Odom family.)

Steve Prather poses as he waits for more neighborhood kids to arrive for a game of sandlot baseball at a house on Woodland Drive in 1967. This yard had base paths worn into the grass from all the games played there in the 1960s and 1970s. (Courtesy of the Prather family.)

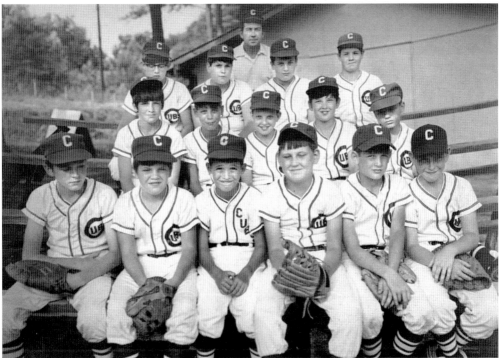

The Cubs pose for a team photograph around 1970 prior to the start of a Pony League game. From left to right are (first row) Tim Frey, Adrian Barron, Richard Kemp (batboy), Mark Carter, Keith Graves, and unidentified; (second row) Mark Barfield, three unidentified, and Billy Pettit; (third row) Remer Halbrooks, David Wells, coach V.G. Prather, David Grant, and Ted Gambrell. (Courtesy of the Prather family.)

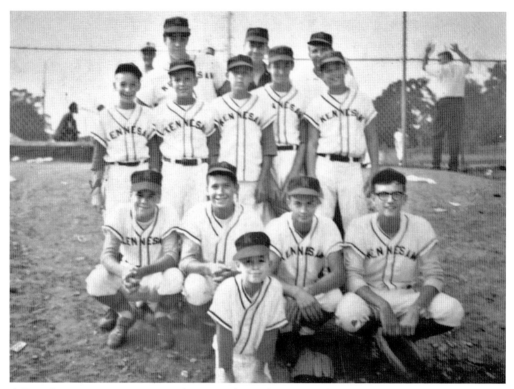

A Pony League team poses around 1968 with coach V.G. Prather. Notice the K for Kennesaw on the hats. Many Kennesaw teams today still honor this legacy with a simple K on their all-star or travel team headgear. (Courtesy of the Prather family.)

A 1970 summer training league scrimmage takes place at Cecil Brown Field, which is known as Field 5 today. It was common in the 1960s and 1970s for players to wear jeans to practice or as part of the uniform during games. There were only two fields in Adams Park until the early 1980s, when the city constructed four adjoining baseball fields (now known as Fields 1–4). (Courtesy of the Prather family.)

ADAMS PARK AND THE KBSA

The Little League Aces load up a pickup truck for the Kennesaw Fourth of July parade of 1972. The teams from Adams Park played a prominent role in local parades and festivities throughout the 1970s and 1980s. (Courtesy of the Prather family.)

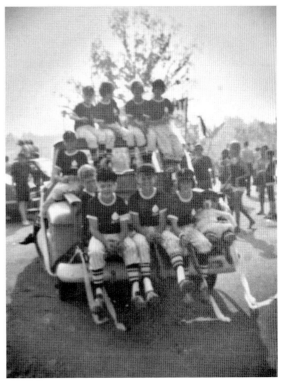

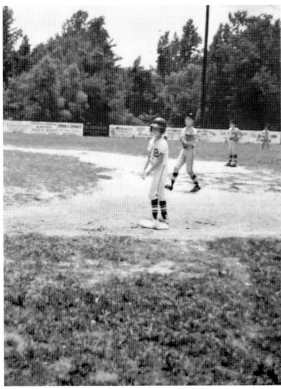

The 1972 Bronco League Cubs get a runner on first base at Cecil Brown Field. The Cubs player on first is Steve Prather, who had just gotten a hit. (Courtesy of the Prather family.)

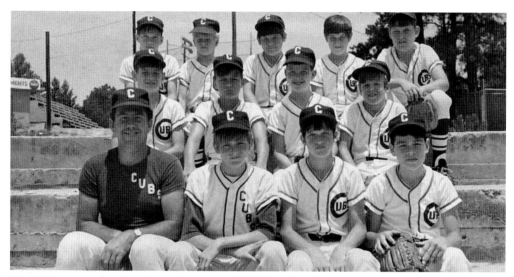

The 1972 recreation ball Cubs pose with coach V.G. Prather. From left to right are (first row) Prather, Tim Frey, Mark Barfield, and Gary Garner; (second row) Keith Graves, Billy Pettit, unidentified, and Billy Honer; (third row) Scott Barfield, Steve Prather, Scott Robertson, Billy Babin, and Mark Carter. As Steve Prather recalls, "This was the last year of Little League. The next year we converted to Bronco League and played on Cecil Brown Field. The difference was in Bronco you could lead off the base, steal on the pitcher (vs waiting until the catcher had possession) along with a few other rules changes. But the big deal to all of us kids is we could wear metal cleats and that was a huge deal at that age (12 and 13 yrs of age)." (Courtesy of the Prather family.)

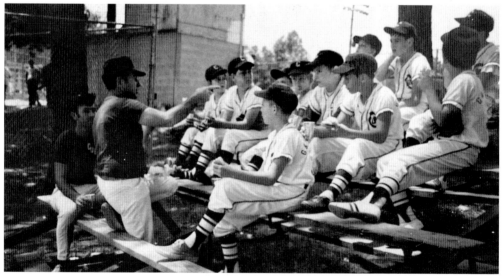

Bronco League players on the Cubs team receive some coaching and feedback on their performance around April 1973. Coach Prather and assistant coach Bill Babin provide pointers on ways to improve the team's play. In the background is the upper field (now Field 6), and the wood structure on top of the dugout is the scorekeeper's box. This was before the concession stand and scorekeeper's area above it were built behind home plate. (Courtesy of the Prather family.)

The 1972 Cubs prepare for an opening day parade through downtown Kennesaw. Notice the modest signs stating "We're the Best Team Around!" and "The Cubs #1." (Courtesy of the Prather family.)

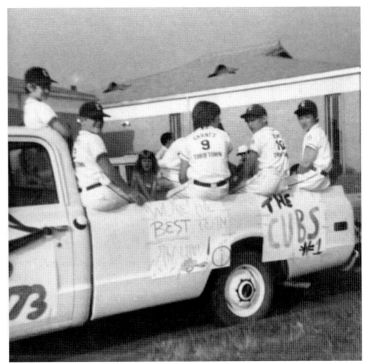

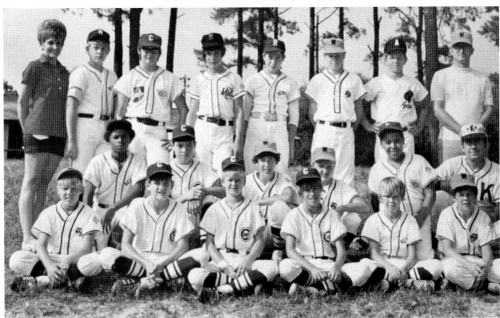

The variety of uniforms shows the Bronco League's selections for the 1973 all-star team. From left to right are (first row) Tim Hopkins, Keith Graves, Steve Prather, Mike Edwards, unidentified, and Ted Childs, (second row) unidentified, Gary Garner, Tim King, unidentified, Willie Austin, and coach V.G. Prather; (third row) unidentified team mom, Mike Yoder, Phillip Hulsey, Reggie Griffith, unidentified, Dan Hood, unidentified, and coach Dan Daniels. (Courtesy of the Prather family.)

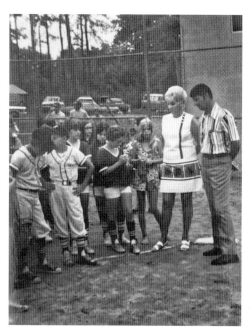

In 1973, Cecil and Virginia Brown visit the field named after him for his generous support to the league and Adams Park. He and his wife were very active and donated their time, money, and in-kind construction for the association. His son-in-law Mike Samples coached many years at Adams. This picture shows the dedication ceremony in which the lower field (now Field 5) was named after Brown. Baseball and softball players assembled for the dedication, as both used the field for games and practice. The girl is Mary Bentley, who played softball in the Adams Park league. The Bentley family was very active in Kennesaw sports, including her parents and three brothers, Bobby, Mark, and Tim. (Courtesy of the Prather family.)

The KBA 1973 All-Stars pose for a team photograph. From left to right are (first row) Billy Honer, Robert Davis, Tim Hopkins, Steve Prather, and Monte Wood; (second row) Scott Robertson, Mark Greene, R.J. Coolidge, Greg Haley, Norman Dallago, and Eddie Goodwin; (third row) Gary Garner, Willie Austin, Randy Priest, Robbie Carrier, unidentified, coaches Mike Samples and V.G. Prather, and unidentified. Steve Prather recalls, "Red and Blue only had the significance of dividing the teams because back in those days, a lot of times you only had one 13–14 year old team but when we had enough for two teams they just had a 'Red' and 'Blue' team. Same with All-star teams—one year they decided to put two teams in the All-Stars so we had a red and a blue team." (Courtesy of the Prather family.)

ADAMS PARK AND THE KBSA

A 1973 all-star game is underway at Cecil Brown Field in front of parents. This shot is from the third base side looking up toward where Field 6 is today. (Courtesy of the Prather family.)

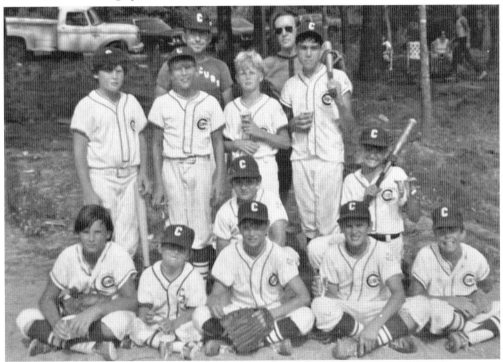

The Bronco League Cubs pose for a c. 1973 photograph. From left to right are (first row) unidentified, batboy Steve Payne, unidentified, Danny Whittle, and Billy Honer; (second row) Barry Payne and Terry Whittle; (third row) Scott Robertson, Greg Haley, Steve Prather, Gary Garner, coach V.G. Prather, and assistant Bill Honer. (Courtesy of the Prather family.)

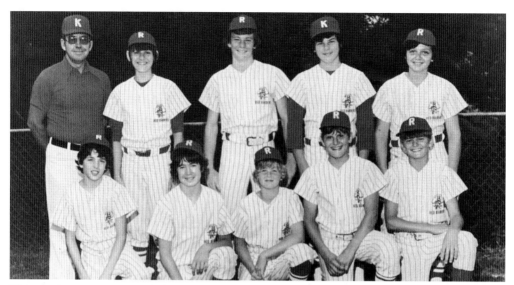

The 1975 Pony League only had two teams: the Red Raiders and the Blue Raiders. From left to right are (first row) Marc Chumley, Mike Cronin, Steve Prather, Danny Whittle, and Terry Whittle; (second row) coach V.G. Prather, Barry Payne, Paul Guthrie, Scott Robertson, and Harold "Hal" Leonard. (Courtesy of the Prather family.)

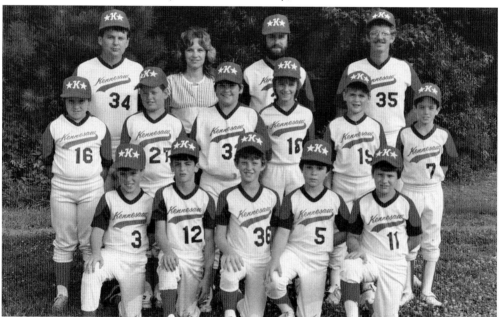

The 1985 Kennesaw All-Stars pose for a team photograph. From left to right are (first row) Jason ?, Sean McClesky, Jonathan Colston, Ben O'Dell, and Russ Piper; (second row) Matt Bridges, two unidentified, Jason Blalock, Shipp Hollis, and Michael Todd; (third row) coach Hollis Todd, Patricia Zett, Coach Gary Zett, and coach Bob Colston. Blalock would later letter in baseball, football, and basketball at Harrison High School. Bridges also lettered in baseball at Harrison High School and was Pitcher of the Year. (Courtesy of the Graham-Bridges family.)

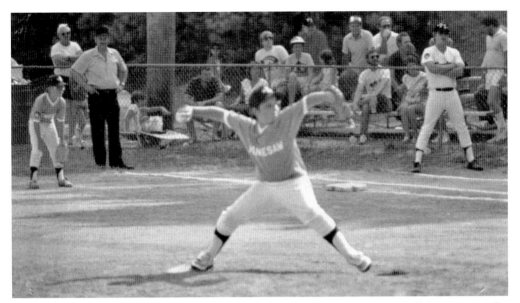

Matt Bridges pitches in a 1986 all-star game. In recent years, youth baseball has instituted a pitch count to limit the number of pitches a player can throw in an effort to prevent injury, but this was not so during Bridges's era. In 1986, he would routinely pitch a six-inning game. For the season, Bridges threw six no-hitters and one perfect game. The team won both the district and state championship that year. (Courtesy of the Bridges family.)

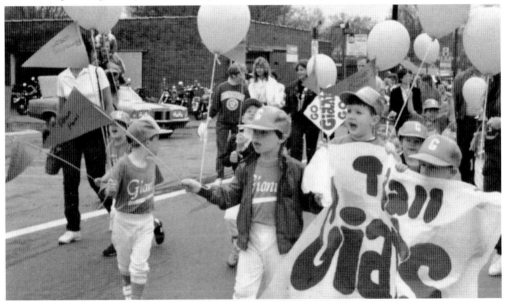

Opening day used to be a big deal in Kennesaw and featured a parade by players and families from city hall to Adams Park. Here, the KBA's opening day parade progresses through downtown Kennesaw parallel to the railroad tracks on April 11, 1987. The brick building in the background has served a number of purposes, including a police station and a Lionel train store. It is currently part of the restaurant Burgerfi. (Courtesy of the Grundhoefer family.)

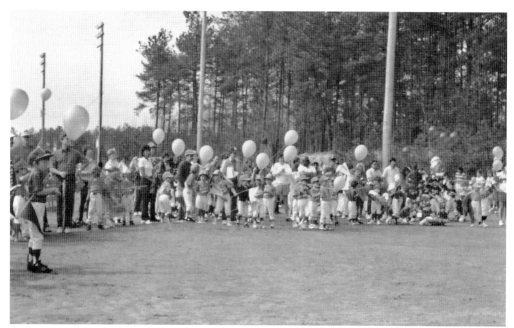

Opening day ceremonies begin the 1987 season where the current Field 3 is (today there is a Publix and strip mall on the other side of the embankment). Notice the light poles that were installed for youth football, which was run by the city. (Courtesy of the Grundhoefer family.)

The five- and six-year-old Chiefs and Giants play ball on Field 1 during the first game of the season on April 11, 1987. Stephen Grundhoefer runs to second base. In 1987, Field 1 was oriented differently from today—home plate was in what is now right field. (Courtesy of the Grundhoefer family.)

In this c. 1988 photograph, Adams Park has been converted to a football field. Every fall, two of the Adams Park baseball fields would be temporarily converted into a football field to support the league. Not only did the KBA use the name "Generals" for its all-star teams, the city also named its youth football teams after the famed Civil War locomotive. The city stopped organizing a football field once Kennesaw Mountain High School began a youth football league shortly after its opening in 2000. (Courtesy of the Grundhoefer family.)

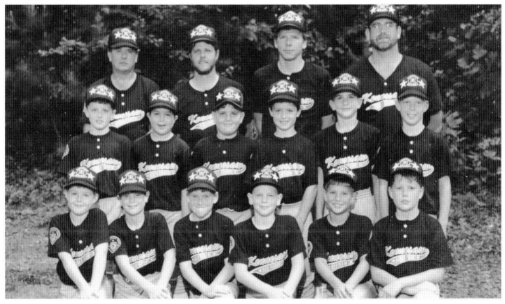

The 1991 Kennesaw Blue Mustang All-Stars pose for a team photograph. From left to right are (first row) Trey Palmer, unidentified, Russ Jones, Dexter Cooper, Michael Baker, and Stephen Grundhoefer; (second row) Matt Mazikowski, unidentified, Steven Futral, Kyle Counts, Jonathan Nelson, and unidentified; (third row) coaches Steve Milton, Ed Palmer, Russ Jones, and Chuck Counts. Mazikowski would go on to play for LaGrange College. (Courtesy of the Grundhoefer family.)

Around 1996, the 10-year-old Kennesaw All-Star team poses for a photograph. The team achieved a 27-3 record and was runner-up in the state championship. From left to right are (first row) Marty Worley, Andrew O'Neil, Ben Howard, Joseph Cheshire, Jared Greycheck, and Richard Logan; (second row) Jonathan Strickland, Casey Cook, Michael Roseberry, Michael Gauker, Garrett Reedy, and Patrick Gilley; (third row) coaches Randy Cheshire, Lee Strickland, Dennis McCoy, and Mark Cook. (Courtesy of the Grundhoefer family.)

Members of the 2000 Mudcats pose after winning a T-ball game. From left to right are Reed Curtis, Charlie Tull, Noah Smith, Colin LoCurto (junior coach), Noah Rymutt, Mitch Ledford, Christopher LoCurto, and two unidentified. The coaches are Ken LoCurto (left) and Rich Tull (right). Colin LoCurto played for Kennesaw Mountain High School and pitched for Georgia College from 2016 to 2018. (Courtesy of the LoCurto family.)

Dansby Swanson fields a ball during an all-star game on the road around 2001. Swanson played at East Cobb Baseball, Marietta High School, Vanderbilt University, and finally in the major leagues as a Diamondbacks draftee and then with the Atlanta Braves. His journey inspires many young area players today, and his storied ascension to baseball greatness fuels many youthful dreams of making it big. (Courtesy of the Swanson family.)

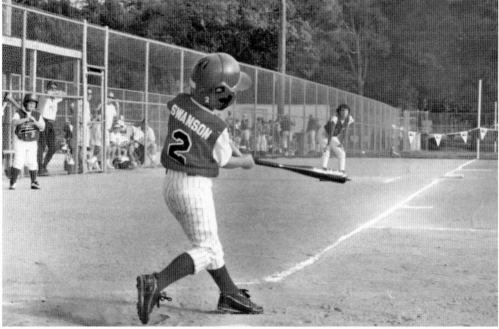

Dansby Swanson bats around 2002 in an all-star game representing Adams Park. His mother, Nancy Swanson, was heavily involved in his baseball development and is seen coaching third base during this game. Dansby's father, Cooter Swanson, coached a 17-year-old team at East Cobb, which required Nancy to stand in for him as a coach. By all accounts, she was an excellent coach in her own right. Note that Dansby is wearing a number 2 jersey, which he wore again as a rookie in 2016 for the Atlanta Braves before changing to his preferred number 7 in his second year in the big leagues. (Courtesy of the Swanson family.)

Tyler Stephenson played at Adams Park from age four through seven (fall 2000–2004). He had many coaches throughout his career at Adams, including his father, David Stephenson, who was his coach when he played for the recreation baseball team the Reds. Tyler was later drafted by the Cincinnati Reds in 2015. He played on the all-star teams for the three and a half years he was at Adams Park. His coaches were Jeff Turner, Art Evans, Bubba Atkinson, and Rusty O'Cain. (Courtesy of the Stephenson family.)

In this 2007 photograph, Tyler Rhodes and his father, Doug Rhodes, pose after his 11-year-old Kennesaw Generals team won the Kennesaw Classic championship, an annual tournament at Adams Park hosted by the KBA's summer all-star teams. People like Doug Rhodes epitomize a passion and dedication for the sport. He was a league coach from 2001 to 2018, president of the KBA from 2008 to 2017, and has continued to stay active as an umpire from 2018 to the present. (Courtesy of the Rhodes family.)

The KBA's 2013 fall team, the Rays, pose for a season photograph. From left to right are (first row) D.J. Sanders, Brodie Jones, Jacob Frith, Austin Schubert, Paul Telle, and Adam Blair; (second row) coach Ed Hunda, coach Ken Mills, Zach Mills, Chris Vecchio, Tyler Frith, Tate Hunda, Zach Opitz, Luke Martin, coach Mike Martin, and head coach Derek Easterling. Easterling coached at Adams Park from 2007 to 2019. He was elected mayor of Kennesaw in 2015 and remains an avid supporter of youth baseball and youth sports in general. (Courtesy of the Easterling family.)

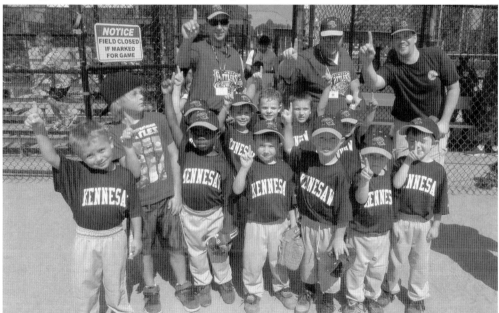

This photograph captures the love of baseball with new players in T-ball in 2013. The five- and six-year-old Rattlers played fall ball that year. From left to right are (first row) Barrett Tubiak, unidentified, Dante Jones-Jackson, Graham ?, Lawson Buresi, Stephen Ogburn, and Josh Howell; (second row) Skyler Joldersma, Scott ?, Aiden Hamilton, unidentified, and Owen Williams; (third row) coaches Brian Tubiak, John Williams, and Cameron Howell. (Courtesy of the Tubiak family.)

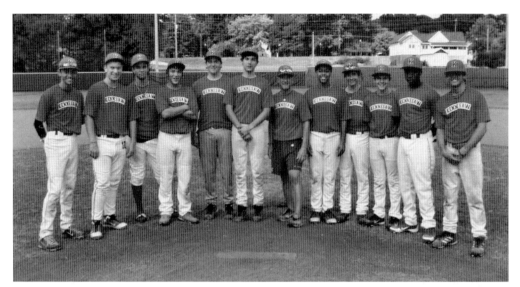

The 2013 KBA senior team poses for a photograph to celebrate its undefeated season. From left to right are Colin LoCurto, Tyler Rhodes, José Hart, Blake Mayo, Thomas Petraska, Dakota Kivett, coach Doug Rhodes, Riley Reed, Cody Buchanan, Austin Hogan, Gary Benson, and Hayden Fox. Significant team achievements included the North Cobb Inter-League championship and the Battle of Main Street tournament championship, hosted by Acworth. (Courtesy of the Rhodes family.)

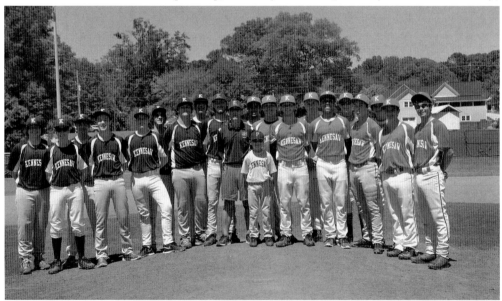

Players gather for the 2014 opening day ceremony on Field 6. From left to right are Tyler Womack, Christopher Vanessendelf, Adam Fincher, Riley Brooks, George Peshel, Logan Hussain, Reed Campbell, Eric Zimmerman, Dakota Kivett, coach Doug Rhodes, batboy Kyle Robitzsch, José Hart, Blake Mayo, Hayden Fox, Tyler Rhodes, Riley Reed, Jacob Frith, Christopher Stroud, Donald Coe, Chase Harrington, and Cody Buchanan. Teams were "creatively" named Kennesaw Blue and Red. (Courtesy of the Rhodes family.)

ADAMS PARK AND THE KBSA

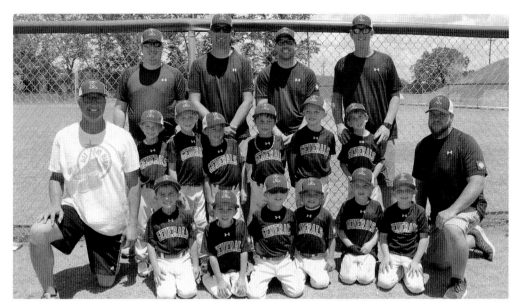

The 2015 five-year-old Kennesaw Generals All-Stars pose for a picture. From left to right are (first row) coach Brian Watkins, Jacob Jones, Killian Boyd, Will Park, Lucas Hulsey, Rolan Gyson, Grayson Prewitt, and coach Mark Hulsey; (second row) Nolan Sprayberry, Jett Miller, Bryson Langley, Charlie Lowe, Parker Watkins, and Kellum Typer; (third row) coaches Daniel Jones, Chris Miller, Mark Prewitt, and head coach Zach Typer. (Courtesy of Marcia Rooks.)

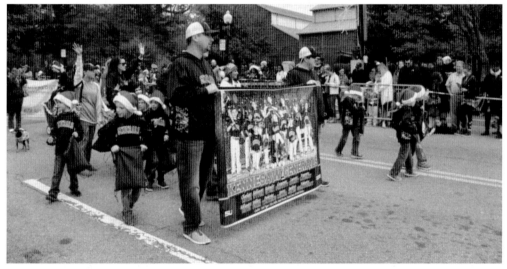

While opening day parades for Adams Park are a thing of the past, the KBA routinely participates in other city parades. In this 2015 photograph, the five-year-old Kennesaw Generals All-Stars march in the Kennesaw Christmas parade, handing out candy canes to bystanders. Holding the Kennesaw Generals banner are coaches Chris Miller (left) and Daniel Jones. In the background is the Southern Museum of Civil War and Locomotive History, which houses the league's all-star and travel ball namesake, the *General*—a Civil War–era locomotive that serves as the central attraction at the museum. (Courtesy of Marcia Rooks.)

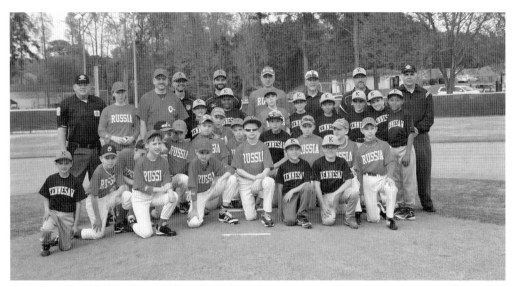

On March 30, 2016, Adams Park and the KBA hosted an exhibition game between 12-year-old players from Russia and Kennesaw who put international politics aside to enjoy the camaraderie and love of the sport. The Russians were sponsored by the Atlanta International Umpires, a group that officiates youth and adult baseball leagues. Additionally, the Russian team and parents attended games at Turner Field to see the Atlanta Braves, Georgia Tech, and Kennesaw State University. A scrimmage between a Russian team and the Kennesaw Express in April 2018 was organized by Doug Rhodes and Ken Vanderpool of Atlanta International Umpires. Vanderpool hosts teams from Eastern Europe once a year when they come over and play various parks. (Courtesy of the Rhodes family.)

The eight-year-old Kennesaw Generals All-Stars advanced from a field of 32 teams to the 2016 Dizzie Dean World Series elite eight at Snowden Grove Park in Southaven, Mississippi. After having just won the game that got them into the elite eight, the boys race to the uniform shop to be fitted with their new jerseys. From left to right are Troy Gross, Will Reed, Austin Gross, Sam Castleberry, Carter Sams, Amy Reed (riding in back of golf cart with Ben Reed), Caleb Bridges, Brody Wilkes, coach Dennis McCoy (passenger seat), Thomas Caudill, Dalton McCoy, Gavin Sams, John Arnold, and Ryan Brooks. (Courtesy of the Caudill family.)

In this 2017 photograph, coaches Chris Miller (left) and J.R. Owens talk to their six-year-old team after a spring farm league game. The T-ball and farm leagues feature some of the most charming baseball, as this is where the basic fundamentals of the sport are learned. Some players are laser focused, some spin in circles in the outfield, and all look forward to a snack after the game. (Courtesy of Marcia Rooks.)

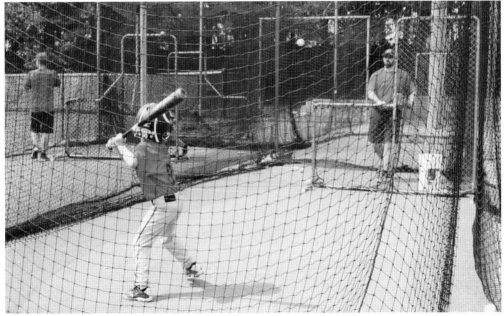

Coach Stephen McGrew gives batting instruction to player Barrett Tubiak in preparation for a 2017 game. McGrew and his wife, Jennifer, have volunteered countless hours of fundraising and organizational work to benefit the KBA. Volunteer leaders like the McGrews are critical to a vibrant and growing program. There were often three generations of McGrews at Adams Park coaching or volunteering in some capacity. (Courtesy of the Tubiak family.)

The Sea Dogs prepare to take the field with a pregame chant during the fall 2017 season. In the fall, the KBA recreation league uses minor-league team names like the Portland Sea Dogs, Louisville Bats, Charleston River Dogs, and Bowling Green Hot Rods. Coaches are, from left to right, Brian Tubiak, head coach Stephen McGrew, Shannon Caudill, and Brad Hutchinson. (Courtesy of the Tubiak family.)

Baseball has changed over the years and become more inclusive. In May 2018, coach Brandi Schnute led her six-to-eight-year-old players to win the KBA's Spring Farm League championship, losing only one game during the regular season. From left to right are Nicholas Caudill, Nicholas Maier, Tyler Lowe, Carson Greb, Brandi Schnute, Colten Crocker, Bryson Brooks, Easton Fischer, Dyson Sparks, and Henry Burmester. Coach Schnute played Division I softball at the University of North Carolina at Greensboro and was a high school softball coach in North Carolina and Georgia before coaching her boys in baseball. She observes, "Over my years of coaching no one ever seemed bothered that I was a woman. They may have thought it when they found out who their kids' coach was, but I think once they saw my knowledge, passion, and excitement for the game they didn't care." (Courtesy of the Schnute-Sparks family.)

The 12-year-old Kennesaw Express team enters the field at Cooperstown for the 2017 annual national competition. From left to right are Brady Clark, John LoCurto, Derek Brooks, Cameron Chastain, and Sam Sacchetta. LoCurto and Brooks later played for Kennesaw Mountain High School and North Cobb High School, respectively. (Courtesy of the Brooks family.)

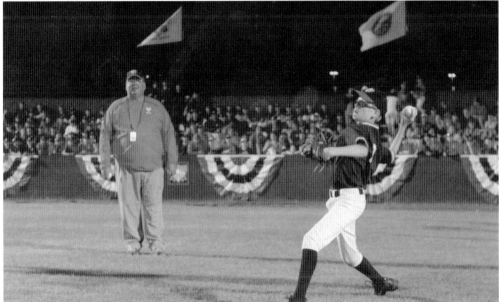

Derek Brooks competes in the Cooperstown Golden Arm competition in 2017. He finished first out of 104 competitors (each team sent its best) on June 23, which also happened to be his birthday. Each participant was given three throws from center field at a distance of 125 feet from home plate, where there was a bullseye target. Points were awarded based on how many hit the target in the air and how close the balls were to center. Three rounds narrowed it down to the top five. The final round was held at Little Majors Stadium at Cooperstown in front of a capacity crowd. (Courtesy of the Brooks family.)

Field 6 at Adams Park was dedicated as Doug Rhodes Family Field in August 2018 in recognition of Rhodes's retirement and his family's commitment to the KBA. The young men in the picture had all been coached by Rhodes on teams from age 10 to 18. From left to right are Hayden Fox, Dakota Kivett, Thomas Petraska, Doug Rhodes, José Hart, Blake Mayo, and Tyler Rhodes. (Courtesy of the Rhodes family.)

The 2018 Generals 12U team poses after winning the World Junior Baseball Classic. They won seven tournaments that season, finished as runners-up in the US Specialty Sports Association state championship, and placed third out of 102 teams at Cooperstown's Dreams Park annual tournament. Half of the team had been playing baseball in all-stars together since the age of seven. From left to right are coach Phillip Galbreathach, Jansen Kenty, Cayden Sheffield, Camden Barnes, Bailey Thorne, Wes Parsons, Ryan Maddocks, Mattheson Go, Kyle Robitzsch, coach Doug Rhodes, Makhi Buckley, Wills Maginnis, Cooper McMullen, Carter Galbreath, Nolan O'Connor, and coach Rob Longyear. (Courtesy of the Rhodes family.)

The 7U Kennesaw Express All-Stars line up after their tournament win against the Canton Noles on July 8, 2018. They became the Silver Bracket champions after a hard-fought game that finished 17-16. From left to right are Jacob Jones, C.J. Thompson, Ryver Vangeest, and Connor McGrath. (Courtesy of Marcia Rooks.)

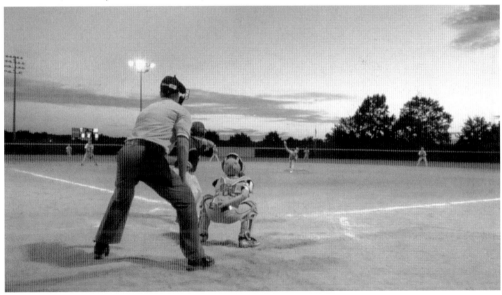

A perfect day of baseball is captured on a fall evening in 2018 at Adams Park, with the 11-year-old Kennesaw Outlaws on the field in a travel ball tournament. Coached by Rich Gross, the team went on to a record of 9-0 with three championships. Players pictured are, from left to right, Troy Gross, Raedan Jones, Ryan Brooks, Jake Barsczc (catching), Thomas Caudill (pitching), John Arnold, and Austin Gross. (Photograph by Morgan Barsczc.)

The 11-year-old Kennesaw Generals travel team shows off their championship rings after winning top honors at the 2019 Training Legends Georgia World Series tournament. From left to right are (first row) Jordan Littles, Braylon Urquhart, Chance Williams, Hunter Dillard, James Lowe, Jennings Allen, and Jordan Sanders; (second row) Turk Williams, Skyler Joldersma, Hap Fleming, and Zachary Simmons. Coached by Joey Williams, this team had a perfect fall 2019 record, playing up one level against 12-year-old teams. They also won two of three tournaments against players one year older. They finished 2019 ranked as the number-twelve 11-year old travel ball team in the country by *Perfect Game* and the number-one travel ball team at this age in the state of Georgia by *Travelballselect*. (Courtesy of Joey Williams.)

Coach Joey Williams and his son Chance pose after winning the Perfect Game 2019 Easter Shootout tournament. Coach Williams and this team started the slogan "#RespectTheK," which has served as motivation for all teams to represent the city of Kennesaw and Adams Park with their utmost effort and dedication to the sport. Williams is an example of the outstanding coaching talent at Adams Park. (Courtesy of Joey Williams.)

Nathan McLaughlin gets the out at second and tries to turn a double play in the 2019 nine-year-old Dizzy Dean state championship. The team went on to beat the East Side Thunder 8-7 for the championship. (Courtesy of Marcia Rooks.)

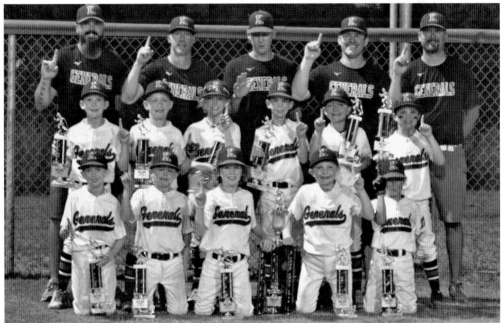

In 2019, Adams Park was well represented with its eight-year-old team, which won the Dizzy Dean state championship. From left to right are (first row) Nolan Sprayberry, Jackson McKneely, Eli Pullen, Grayson Prewitt, and Liam Mowdy; (second row) Jett Miller, Bryson Brooks, Parker Williams, Kellum Typer, Talon Wright, and Nathan McLaughlin; (third row) coaches Scot McKneely, Greg Brooks, head coach Zach Typer, Sean Wright, and Chris Miller. Typer has served as the president of the KBA since 2017. (Courtesy of Marcia Rooks.)

Lathan Boshell of the Kennesaw Express takes a look at home plate coverage after rounding third base during a 2019 tournament against Bats Baseball. Adams Park continues a nearly 60-year history of developing top-notch players like Lathan in its recreational leagues, all-star teams, and travel ball programs. Whether players remain in Adams Park programs or move on to other respected developmental programs in the area, the KBSA and its predecessors can boast giving quality fundamentals to many marquee players like Dansby Swanson and Tyler Stephenson. (Courtesy of Rachael Nelson.)

Current players and alumni of Adams Park pose for a 2020 photograph with the *General* at the Southern Museum of Civil War and Locomotive History in downtown Kennesaw. Adams Park's all-star and travel ball teams (and football teams when the city ran a football league at Adams Park) are named the Generals and feature a train logo in tribute to the famed locomotive. From left to right are Parker Watkins, Kenzie Allman, Landon Allman, Noah Smith, Henry Smith, Tucker Smith, Christian Scragg, Jacob Fowlkes, and Thomas Caudill. (Photograph by Shannon Caudill.)

4

NORTH COBB HIGH SCHOOL

1961–PRESENT

North Cobb High School was the lone Kennesaw high school for nearly three decades and was built when the area was still largely rural. Its baseball program can be summed up as "The House that Coach Cochran built." Harvey Cochran was the longest serving baseball coach in North Cobb High School history, with 35 years of service in that role. He built the program from the ground up and eventually led the Warriors to seven regional championships. He won 571 games at North Cobb, with an overall 682-348 record at four high school programs. His career still stands as the sixth-most wins in the history of Georgia baseball coaches as of 2020. In 2013, North Cobb High School named its baseball field Harvey Cochran Field and retired his No. 40 jersey in tribute to his leadership and impact on baseball. In 2015, he was honored by the Georgia Athletic Coaches Association with his induction into its hall of fame. "I love coaching high school baseball," Cochran told the *Marietta Daily Journal*. "It's baseball at its purest form." Cochran had a profound impact on the other programs as the new high schools began fielding teams and served as the benchmark for excellence that others sought to emulate. Tom Callahan served as an assistant coach under Cochran and took over the team in 2006. Since taking the head coach role, Callahan has led North Cobb to the Georgia state playoffs 11 times in 15 years, including the final four in 2008, the elite eight in 2012, and the sweet sixteen in 2010 and 2014. Callahan was selected to coach in the Georgia Dugout Club State All-Star Series in 2005 and again in 2013. Since 1972, North Cobb has produced over 131 college-level baseball players and 21 players and coaches honored by the Braves 400 Club.

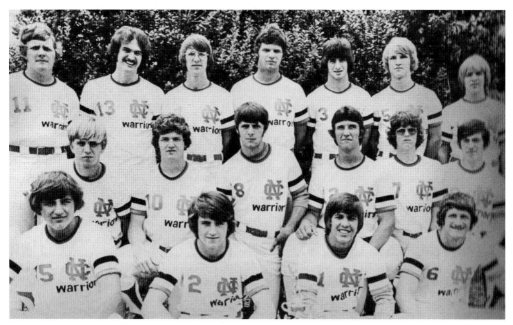

The North Cobb Warriors pose for a team photograph around 1976. From left to right are (first row) Ricky Hardin, Bobby Austin, Calvin Diemer, and Sammy Callahan; (second row) Billy ?, Ted Gambrell, Eddie Page, Cecil Brown, Herb Hendricks, and Frank Millerd; (third row) Monte Long, David Grant, Mike Jones, Tony Key, Pete White, Jeff Austin, and Ricky Delaney. Pete White went on to play at Mississippi State and in the College World Series. Calvin Diemer played for Middle Georgia College and now owns Days Chevrolet in Acworth. (Courtesy of North Cobb High School.)

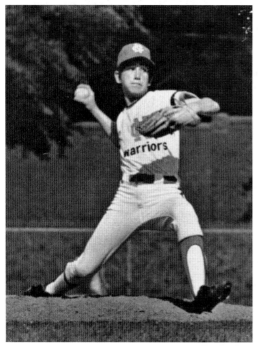

North Cobb's Frank Millerd delivers a pitch around 1977. Millerd was later named an All-American, played baseball for Mercer University, and served in the US Army as a helicopter pilot in Iraq. (Courtesy of Harvey Cochran.)

Coach Harvey Cochran congratulates North Cobb High School player Mark Stewart on a home run in early 1982. Stewart still holds the North Cobb record for most runs batted in, with 47 for the 1983 season. He went on to play for Dekalb College. (Courtesy of Harvey Cochran.)

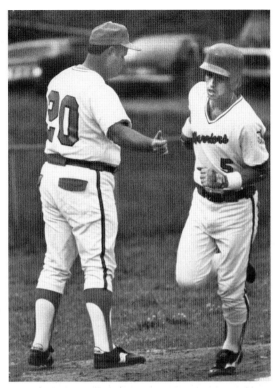

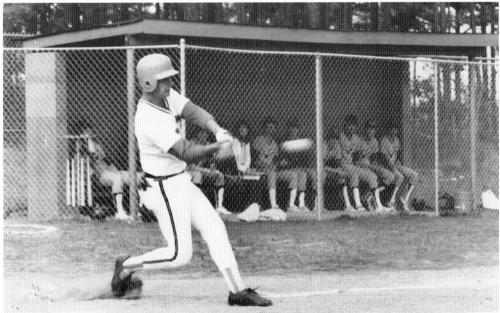

Kyle Reese gets a hit in 1983. Reese was later drafted by the Braves and played minor-league baseball for the Braves, St. Louis, and Kansas City from 1983 to 1991. He then coached the Mount Paran Christian School team, replacing his mentor and former coach Harvey Cochran in 2013. (Courtesy of Harvey Cochran.)

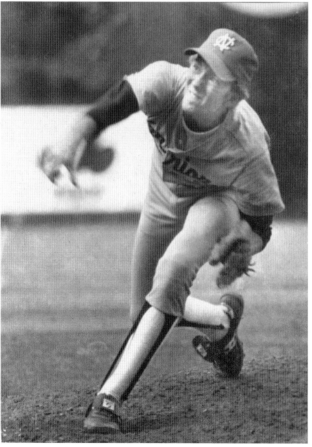

North Cobb players pose before the 1983 regional championship game. From left to right are Marc Stewart, Richard Barnes, Milo Crowe, Denny Volrath, Kyle Reese, David Capalbo, Nick Nickerson, and T.J. True. Stewart and Reese still hold a tied North Cobb school record for home runs, with both earning 14 in the 1983 season. (Courtesy of Harvey Cochran.)

Rodney Vollrath throws a strike in 1983, the year he set the school's record for wins at 13-3, which still stands in 2020. Vollrath went on to play for the University of North Carolina. (Courtesy of Harvey Cochran.)

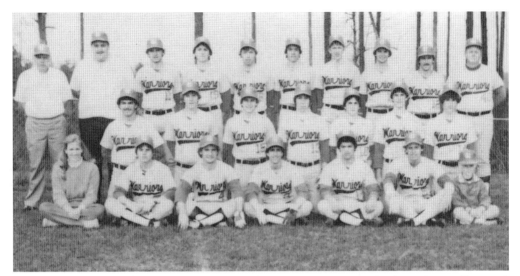

The 1983 Region 5-AAAA champions pose for a photograph. From left to right are (first row) Nevanne Hensley, Richard Barnes, Alan Ashley, Lorin Coles, Miles Crowe, Mark Stewart, and Kip Cochran; (second row) Robert Fuller, Lee Raines, David Capalbo, Jeff Raines, Nick Nickerson, Darryl Fulton, and Russell Crawford; (third row) coach Durant Reese, coach Joel Blair, Kyle Reese, Chris Barnes, Denny Vollrath, Matt Slocum, Rodney Vollrath, T.J. True, Marty Mazikowski, and coach Harvey Cochran. (Courtesy of Harvey Cochran.)

Coach Harvey Cochran leads the 1983 All–Cobb County baseball team. From left to right are (first row) Craig Watson, Bobby Verdin, Thomas Panter, Teddy Williams, and Mark Stewart; (second row) Kyle Reese, Todd Gustavison, Terry Kastner, Darrin Linder, Doug Cox, Rodney Vollrath, and coach Harvey Cochran. Not pictured is Mike Gambacini. (Courtesy of Harvey Cochran.)

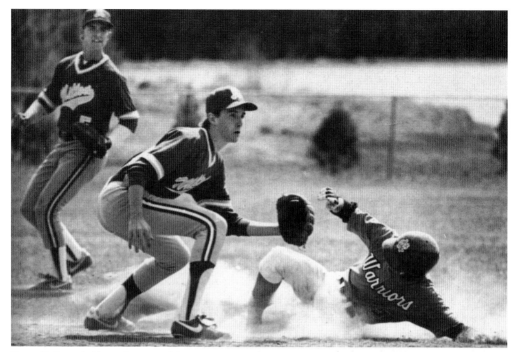

Russell Crawford steals second base against Milton High School but is tagged out by Milton's second baseman, John Wilson, in an early 1985 game. Crawford was named to the 1986 Georgia Dugout Club. (Courtesy of Harvey Cochran.)

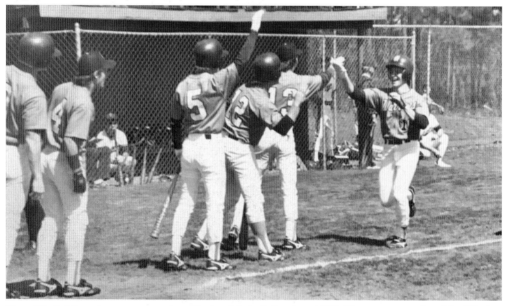

Tom Clark hits a home run against Tucker High School in 1987. He is congratulated by Wesley Adams (13), Robert Ledbetter (12), Michael Fraker (5), Brad Strickland (4), and Ed Evans (8). Clark still holds the school's single-season batting average record at .500, set in 1988, and was selected all state. He later became an assistant coach at North Cobb High School. (Courtesy of the Clark family.)

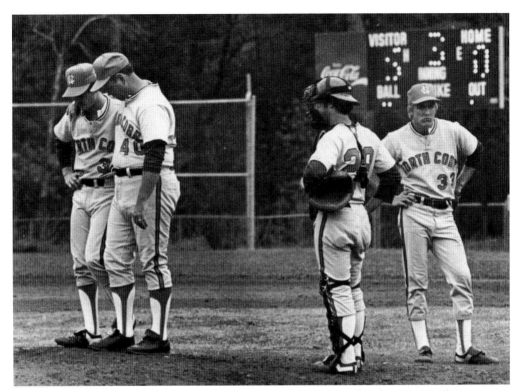

Coaching is an art and focuses on player growth. Nothing is more instructive than tough games in which players face high-pressure situations. In this April 1987 photograph, coach Harvey Cochran takes a moment to talk to pitcher Kyle Jones when down five runs with the bases loaded and one out. Catcher Greg Goodwin and first baseman Gary Hufstetler look on. (Courtesy of Harvey Cochran.)

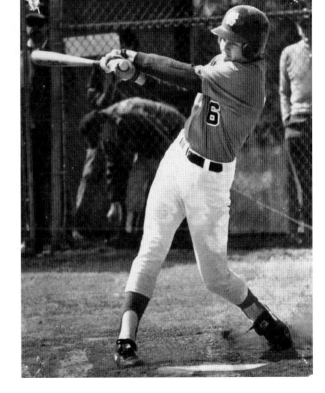

North Cobb's Marc Shaw connects for a hit in 1988. Shaw went on to play baseball for the University of North Carolina in 1990. (Courtesy of Harvey Cochran.)

BASEBALL IN KENNESAW

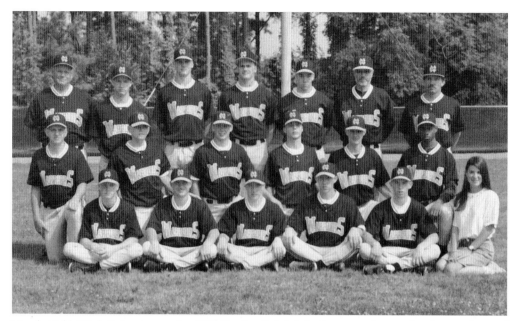

North Cobb High School won the 1993 Region 5-AAAA championship under the coaching of Harvey Cochran. From left to right are (first row) Jeff Wilson, Dusty Folsom, Chris Hall, Justin McGill, Bryan Roper, and Kasey Duff; (second row) Jamie Pelfrey, Ronnie Boggs, Tommy Meek, Boone Holcomb, Jason Cheatham, and Robert Hatcher; (third row) coach Harvey Cochran, Matt Strickland, Eric McQueen, Skip Shipp, Edmund Emerson, coach Mike Moss, and coach Kenny Palmer. Not pictured are Matthew Bird and Ryan Walker. (Courtesy of North Cobb High School.)

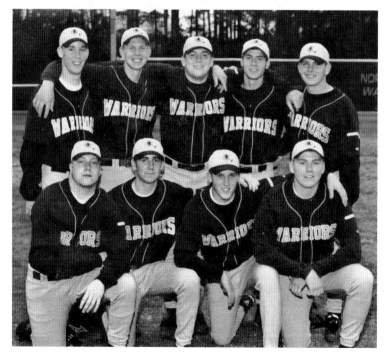

Seniors from the class of 2000 pose for a photograph in their final season. From left to right are (first row) Jason Callis, Eric Johnson, Craig Brock, and Stephen Grundhoefer; (second row) Jeramie Brown, Brian Jones, Jeff Milton, Zach Moseley, and Adam Helms. (Courtesy of North Cobb High School.)

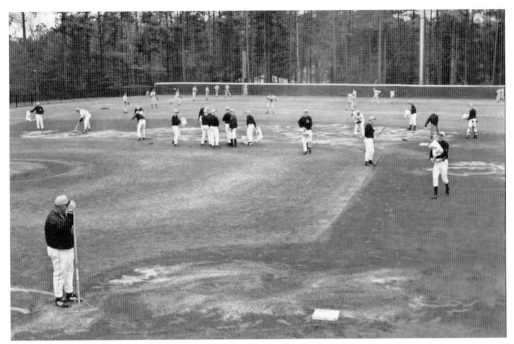

North Cobb High School players and coaches prepare the field for the season in February 2000. Notice Coach Cochran leading by example as he preps the third base area. (Courtesy of the Grundhoefer family.)

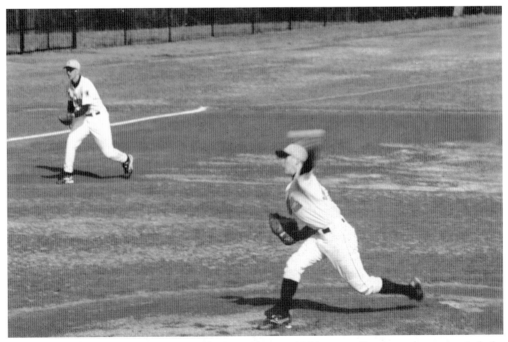

Jeramie Brown pitches for North Cobb in a February 2000 game. Brown went on to pitch for Southern Tech. (Courtesy of the Grundhoefer family.)

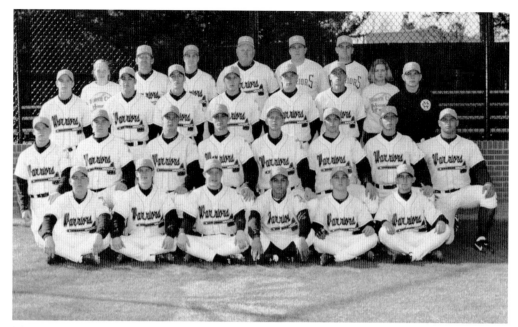

The 2000 North Cobb High School baseball team poses for a photograph. Steve Grundhoefer is at bottom left. Coaches are, from left to right in the fourth row, Kenny Palmer, Tom Callahan, Harvey Cochran, and Keith Hansen. (Courtesy of the Grundhoefer family.)

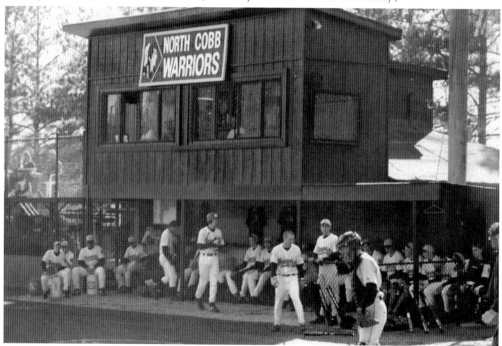

This photograph captures the North Cobb Warriors field facilities around 2000. The field was named after Harvey Cochran in 2013 in tribute to his 35 years coaching at North Cobb. (Courtesy of the Grundhoefer family.)

Brothers George (left) and Keith Hansen were North Cobb players and assistant coaches. Both coached their own high school teams. Keith has coached Allatoona and Alexander High Schools with an overall record of 317-121 and honors as the regional Coach of Year in 2011 and 2014 through 2017 as well as Marietta Umpire Association Coach of the Year in 2016. George coached Kennesaw Mountain High School and was recognized by the Georgia Dugout Club for reaching the milestone of 300 career wins. In January 2019, George was inducted into the Georgia Dugout Club Hall of Fame. His Mustangs have won four regional championships with one elite eight, two final four, and one runner-up finish in the state playoffs. (Courtesy of Harvey Cochran.)

North Cobb 2003 seniors pose for a photograph. From left to right are (first row) Mike Kellar, Jonathan Robinson, Ricky McDaniel, and Matt Hopkins; (second row) Andrew Einert, Spencer Sharp, Edgar Bautista, and C.J. Bressoud, who was drafted later that year by the Atlanta Braves and played minor league baseball from 2004 to 2010. (Courtesy of North Cobb High School.)

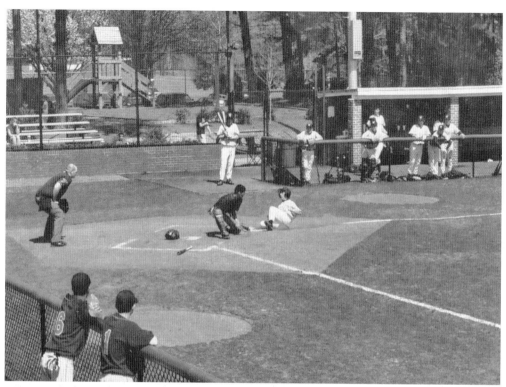

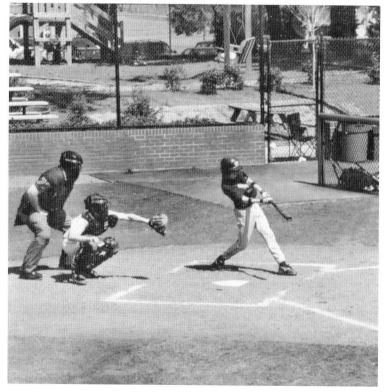

In junior varsity action from 2005, Gerardo Mancilla applies the tag on a play at the plate. Notice how open and close to the action the dugouts once were. (Courtesy of North Cobb High School.)

A North Cobb player bats around 2005. Tom Callahan was selected to coach in the Georgia Dugout Club State All-Star Series in 2005. (Courtesy of North Cobb High School.)

NORTH COBB HIGH SCHOOL

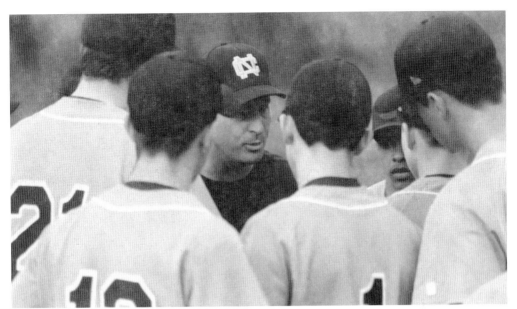

Coach Tom Callahan pumps up his team before a game. Nick Fryman, Jeff Morrow, and Lamar Singh are among the Warriors huddled around Callahan in 2006, his first year replacing coach Harvey Cochran. (Courtesy of North Cobb High School.)

Jonathan Taylor scores yet another run for the Warriors to help advance North Cobb to the 2008 state finals. Taylor led the team in runs scored and stolen bases each year from 2006 to 2008. He has the career record with 100 stolen bases, which puts him in the top 10 in state history. He went on to a stellar career at the University of Georgia and was drafted by the Texas Rangers. (Courtesy of Harvey Cochran.)

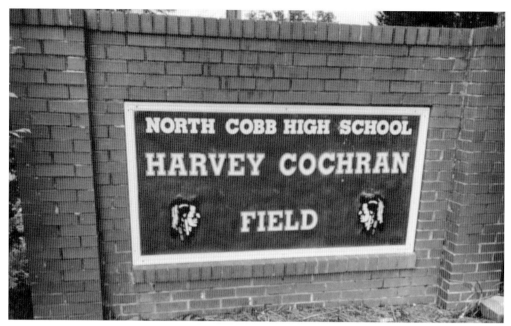

Out of respect and appreciation for the 35 years of coaching Harvey Cochran gave North Cobb, the high school named the baseball field after him. On March 1, 2013, Cochran's No. 40 was retired prior to North Cobb's 4-1 win over Allatoona in a non-region game, and it now hangs on the right-field wall. Cochran posted 571 wins as North Cobb's skipper, won seven regional championships, and led the Warriors to nine regional runner-up finishes. He had just two losing seasons in 31 years. (Photograph by Shannon Caudill.)

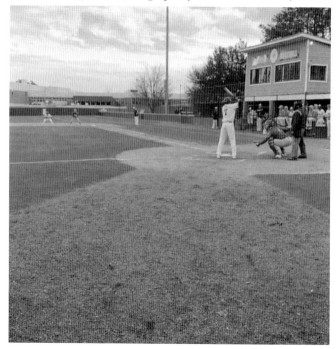

North Cobb faced Walton on a cold Friday evening, February 28, 2020. Unfortunately, the coronavirus pandemic cut the season short, as North Cobb was playing excellent baseball and finished with a 10-3 record. The Warriors played their last game on March 12, 2020. (Photograph by Shannon Caudill.)

KENNESAW STATE UNIVERSITY

1984–PRESENT

The school started as Kennesaw Junior College in 1963, grew, and was renamed Kennesaw College in 1976, then Kennesaw State College, and finally Kennesaw State University (KSU) in 1996. The baseball program began in 1984 with Jim Nash, a former Braves player, as its first head coach. He led the Kennesaw College team to a 30-20 record. In the first year, the team did not have dugouts, outfield fences, or even benches for the players to sit on (they had to be borrowed and carried out from the gym). It was a low-budget start to what would become a powerhouse in college baseball. In 1985, the Owls hired John Barrett as head coach for one season, and he took the team all the way to the NAIA District 25 tournament with a 31-24 record. Chip Reese was hired to coach in 1986 and provided stability to further build the program through 1990. During Reese's tenure with the Owls, Kennesaw College competed in the NAIA District 25 tournament four times and carried an overall record of 145-126-2. In 1991, Steve Givens served as head coach for a season with a 35-25 record and took Kennesaw College to another appearance in the NAIA District 25 tournament. In 1992, the Sansing era began. Coach Mike Sansing has built the team into a nationally recognized program. Since his arrival, Kennesaw has played in seven national tournaments, winning the NAIA national title in 1994 and the 1996 NCAA Division II championship. The team finished in the top four in the nation for its level of play in 1994 (first), 1996 (first), 1997 (fourth), 1998 (second), and 1999 (second). KSU was named the College Division Team of the Decade in 1999 by *Baseball America* magazine. The Owls also appeared in the 2014 NCAA Super Regionals. Eight KSU players have advanced to major-league baseball, including Willie Harris, who played in the 2005 World Series. From 1984 to 2020, fifty-five Owls have been drafted by major-league teams, including Max Pentecost, Chad Jenkins, Travis Bergen, Richard Lovelady, Bo Way, Tony Dibrell, and Grant Williams.

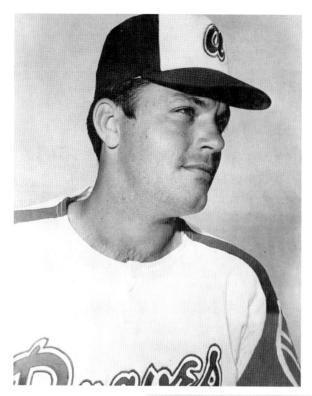

Kennesaw College's baseball program begins with former Braves pitcher Jim Nash. After Nash's baseball career, he decided to complete his bachelor's degree at Kennesaw and graduated in 1982. As he completed his degree, members of the athletics department talked to him about possibly starting a baseball team. Nash agreed and launched the team's inaugural season in 1984. He was ably assisted by coaches Cooter Swanson and Frank Fillman in building the program from the ground up. The team finished a respectable 30-20 in its first season thanks in part to excellent pitching. Kennesaw's Ricky Franke threw two no-hitters in this inaugural season. (Courtesy of the Nash family.)

Chip Reese was hired to coach in 1986 and provided stability to further build the program through 1990. In this photograph, his father, Durant Reese (left), assists Chip during team try-out day in 1987. Durant played semiprofessional baseball in the 1950s for teams in Georgia, Texas, and Kentucky. (Courtesy of the Reese family.)

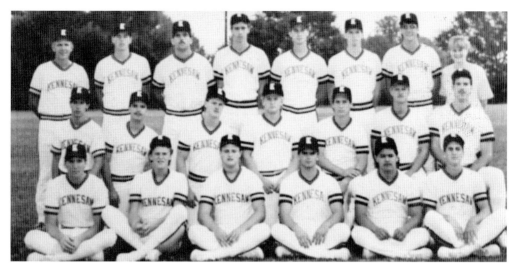

The Owls pose for their 1987 group photograph. The team won the program's first collegiate playoff victory and finished third in the Georgia Intercollegiate Athletic Conference standings. From left to right are (first row) John Kelly, Jeff Haley, Brody Cantrell, Tony Toombs, Miles Crowe, and Jay Mobley; (second row) Mike Smith, Craig Watson, Vic Conn, Darrell McMillian, Pat Daniel, Steve Hays, and Tony Dijockmo; (third row) coach Chip Reese, Steve Mattingly, Tony Kogaklis, Cliff Brannon, unidentified, Scott Firestein, Ricky Frank, and Ginger Paschal. Brannon would be named an All-American, play in the minor leagues, and be inducted into the Kennesaw State University Athletic Hall of Fame. (Courtesy of the Reese family.)

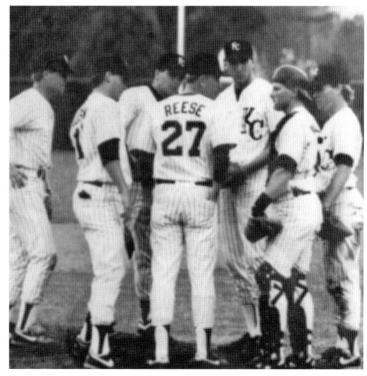

Players huddle on the mound during a 1988 game. From left to right are Todd Pendland, Rod Austin, Tony Toombs, coach Chip Reese, John Kelly, Darrell McMillian, and John Brackett. Darrell McMillian and John Kelly were both named two-time all-Americans. Kelly would later play minor-league baseball for the St. Louis Cardinals and be inducted into the Kennesaw State University Athletic Hall of Fame. (Courtesy of the Reese family.)

Coach Chip Reese observes the action during a 1989 game. During Reese's tenure with the Owls, Kennesaw College competed in the NAIA District 25 tournament four times and carried an overall record of 145-126-2. (Courtesy of the Reese family.)

Coach Mike Sansing accepts the 1994 NAIA national championship trophy. Led by Sansing, the Owls finished the season on a then-school-record 17-game winning streak en route to a 2-0 win over top-ranked Southeastern Oklahoma in the national title game, held at Sec Taylor Stadium in Des Moines, Iowa. Sansing, named Regional and District Coach of the Year, guided the Owls to a 48-14 overall record, including 20-8 in conference play. (Courtesy of Kennesaw State University Archives.)

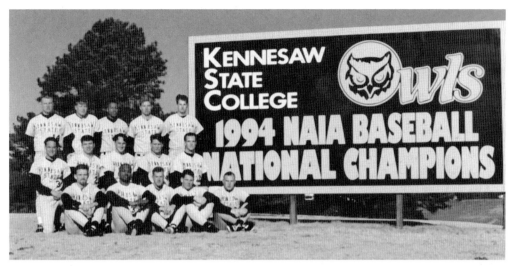

The 1994 NAIA national champions pose near a celebratory billboard placed by Kennesaw State College. Left-handed pitcher Chris McKnight tossed a complete-game, three-hit shutout in the title game, earning him a spot on the All-Tournament team. He was joined on the team by second baseman Darrell Baggett, catcher Ryan Coe, first baseman David Armstrong, and pitcher Todd Kirby. Additionally, Baggett won the Golden Glove Award, while Kirby was named the tournament's MVP. (Courtesy of Kennesaw State University Archives.)

After beginning the 1996 season 5-6, the Owls rebounded, finishing 48-17 to claim their first NCAA Division II national championship with a win over St. Joseph's (Indiana) at Paterson Field in Montgomery, Alabama. From left to right are (first row) Mike Morgan, Steve Reed, Daniel Jordan, Chris Summers, Chris Bowen, Brett Johnston, Brian Mallette, and Greg Perry; (second row) Alex Garcia, Brannon Whatley, Jason Childers, Brian McDevitt, Lem Goodpasture, Nathan Cothran, Stuart Saunders, and Jason Barkwell; (third row) Mike Prokop, Jason Jones, Cajen Rhodes, Derek Perkins, Mike Ivkovich, Matt Houmes, Chris Halliday, and Michael Kalish. Not pictured are Joe Parks, Lance Phillips, Brent Roberts, head coach Mike Sansing, assistant coach Bob Roman, and assistant coach Brady Wiederhold. (Courtesy of Kennesaw State University Archives.)

Chad Jenkins played at KSU from 2007 to 2009. He was drafted by the Toronto Blue Jays in the first round of 2009 and made his major-league debut in 2012. He played for Toronto from 2012 to 2015. (Courtesy of Kennesaw State University Athletics Department.)

Max Pentecost bats in a game at Florida Gulf Coast University in 2014. Pentecost was named to five separate First Team All-American lists while also being named the Atlantic Sun Conference Player of the Year, a first for Kennesaw State University. During the 2014 season, Pentecost led the nation in total hits with 113 and was second in batting average at .422, both of which set new Atlantic Sun Conference and Kennesaw State University single-season records. (Courtesy of Kennesaw State University Athletics Department.)

Travis Bergen played at KSU from 2013 to 2015. He was drafted by the Blue Jays in the seventh round of the 2015 draft and made his big-league debut on March 29, 2019, with the San Francisco Giants. (Courtesy of Kennesaw State University Athletics Department.)

Kennesaw's 2014 team poses for a photograph after defeating Alabama 4-2 to win the 2014 Tallahassee Regional of the NCAA baseball tournament. Bergen pitched 8.2 innings in the win against the Tide on May 30, 2014, and returned three days later to pitch 3.1 innings out of the bullpen to complete KSU's regional win over Alabama. Bergen was named the regional's most outstanding player for his performance. (Courtesy of Kennesaw State University Athletics Department.)

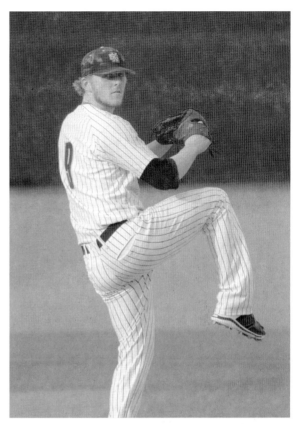

The 2014 Kennesaw State team celebrates its first Atlantic Sun Conference championship win and the first conference title in the university's Division I history. The team finished the season ranked 13th in the nation. Coach Mike Sansing commented, "I felt like we broke the barrier going as far as we did and there's no reason we can't go back again." (Courtesy of Kennesaw State University Athletics Department.)

Max Pentecost stands with hall of fame catcher Johnny Bench as he receives the 2014 Johnny Bench Award, which is presented annually to college baseball's top catcher. Pentecost was selected in the first round of the 2014 Major League Baseball draft. He played in the Blue Jays' minor-league system from 2014 to 2019. (Courtesy of Kennesaw State University Athletics Department.)

Richard Lovelady delivers a strike in a 2016 game. Lovelady played for Kennesaw State in 2016 and finished that season with a 4-3 record and a 2.96 ERA. He was drafted by the Kansas City Royals in 2016 and made his major-league debut in April 2019, pitching in 25 games. (Courtesy of Kennesaw State University Athletics Department.)

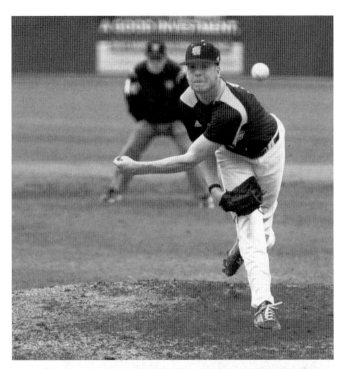

This drone photograph shows a game between Kennesaw and the University of Georgia on February 19, 2020. Kennesaw State University is a unit of the University System of Georgia and is the third-largest university in the state. With a fall 2019 enrollment of almost 38,000, it is now one of the 50 largest public institutions in the United States. (Courtesy of Kennesaw State University Athletics Department.)

Owls pitcher Brayden Eidson comes out of the pen to strike out a St. Peter's batter, ending their threat in the sixth inning of the February 15, 2020, game. Pitcher Monty Horn picked up the win for the Owls, tossing three solid innings that would yield just one earned run. Tyler Tolve earned three hits and four RBIs in the 15-7 win. The Owls finished 2020 with a 10-8 record when the season was cancelled due to the coronavirus pandemic. (Courtesy of the Caudill family.)

Coach Mike Sansing observes from the dugout in a March 3, 2020, game against Brown. After 28 seasons at Kennesaw State, Sansing's career record now stands at 1,121-664 for a .628 winning percentage, which includes a three-year stint as the head coach at Shorter College from 1989 to 1991, when he won 102 games. He has compiled a 1,019-609 (.637) overall record at Kennesaw State since his arrival in 1992, winning his 900th game as KSU's skipper on March 31, 2015, against Western Carolina in a 9-2 victory. (Courtesy of Kennesaw State University Athletics Department.)

6

MOUNT PARAN
CHRISTIAN SCHOOL

1986–PRESENT

Mount Paran Christian School has steadily built an excellent baseball program that really took shape under coaches Harvey Cochran and Kyle Reese in the early 2010s. Reese took the head coaching position in 2013 and won Region 6A Coach of the Year for 2013 and 2018. He spent eight years playing in the minor-league systems of the Atlanta Braves, St. Louis Cardinals, and Kansas City Royals. After completing his stint in the minors, he became the assistant bullpen coach for the Kansas City Royals. As of 2020, under Coach Reese, Mount Paran has won three regional championships, twice finished as Georgia state runner-up, and made seven state playoff appearances. Mount Paran fields four baseball teams for student-athletes from 6th through 12th grade, including varsity, junior varsity, middle school A, and middle school B. Since 2013, Mount Paran has produced 21 players who have moved on to college teams. Mount Paran's baseball program has produced a number of major-league draftees, including Jake Palomaki and Taylor Trammell.

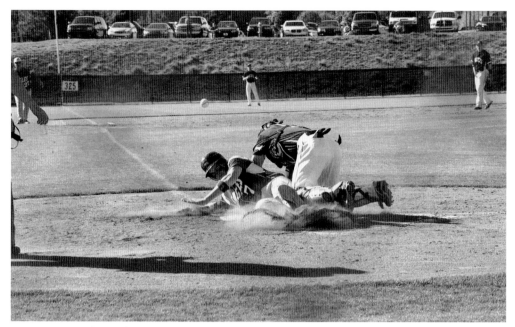

In 2011, Will Schnure slides safely into home in a win against North Cobb Christian. Coach Steve Wilson is at third base and is a former major-league player. (Courtesy of Mount Paran Christian School.)

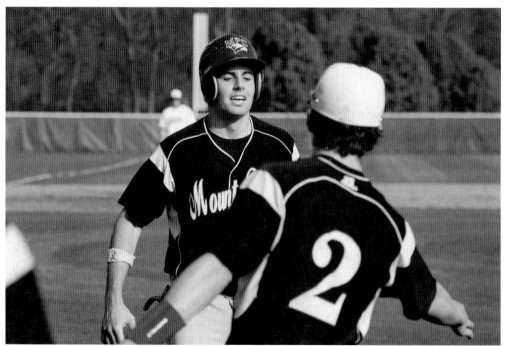

Will Schnure jogs home after hitting a home run against Gordon Lee High School in April 2012 and is congratulated by Jake Palomaki. Schnure later played at the college level for Middle Tennessee State as a catcher. (Courtesy of Mount Paran Christian School.)

In this 2014 photograph, Mount Paran players pose with coaches. From left to right are Cameron Cantwell, coach Kyle Reese, coach Chris Canton, coach Kevin Cunane, Taylor Trammell, Trevor Cumberland, and Jake Palomaki. Trammell and Palomaki would later go on to minor-league careers with aspirations for the major leagues. (Courtesy of Mount Paran Christian School.)

Taylor Trammell zeros in on a fastball in a 2015 game. Trammell has played since 2016 in the minor-league systems of the Cincinnati Reds and San Diego Padres as an outfielder and currently plays for the San Diego Padres' AA affiliate, the Amarillo Sod Poodles. (Courtesy of Mount Paran Christian School.)

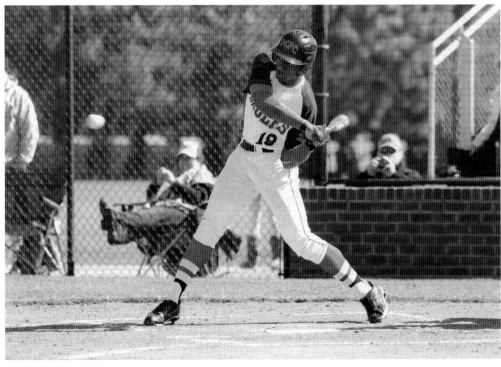

Mount Paran catcher Jack Alexander signed to play with the University of Notre Dame in 2017. Alexander was a four-time all-region player and was selected as all-state during his senior year in 2018. In his 2019 freshman season, he played in 35 games and made 21 starts and had a career-high three hits and three RBIs in a road win against the University of Pittsburgh. (Courtesy of Mount Paran Christian School.)

On March 31, 2017, pitcher Nick Swanson throws to first baseman Austin Ross for a pick-off against King's Ridge Christian Academy, one of Mount Paran's biggest regional rivals. Swanson later played for the University of Missouri and San Jacinto in Houston, Texas. Ross plays for Georgia State University. (Courtesy of Mount Paran Christian School.)

The 2017 team poses for a dugout photograph. From left to right are Zach Feldman, Davis Atkins, Ben Parker, Nick Swanson, Jack Alexander (catcher), Cameron Cantwell, Max Smith (sitting), Trevor Cumberland, batboy Sam Westbrook, Jake Williams (top bench), Hatten Mitchell (thumbs up), Michael Bloodworth, Trevor Brooks, Sean Gilbert, Jack Ryan Wingler, Wood Kimbrough, Kellum Rowan, Hil Kimbrough, Austin Ross, and batboy Tate McKee. Cumberland now pitches for Winthrop University in South Carolina. Mitchell later played for Georgia Highlands in Cartersville. The Kimbrough brothers played for Rhodes College in Memphis (Wood) and Birmingham Southern College (Hil). (Courtesy of Mount Paran Christian School.)

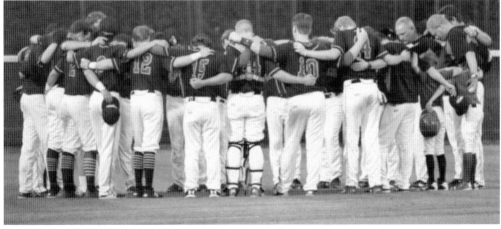

The 2017 team says a prayer after winning the state playoff game against Mount Vernon School and advancing to the elite eight. As a private Christian school, prayer is encouraged at Mount Paran as a root of character and camaraderie. (Courtesy of Mount Paran Christian School.)

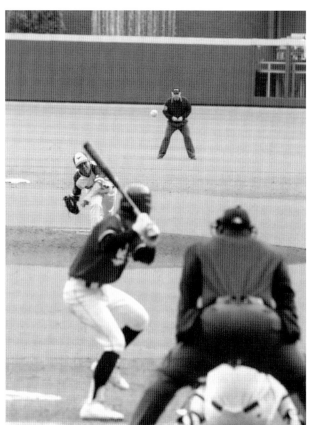

Mount Paran plays a game at the home of the Atlanta Braves, SunTrust Park, on April 9, 2018. On the mound is Zach Feldman pitching against Holy Innocents Episcopal School. (Courtesy of Mount Paran Christian School.)

Baseball is not just a sport but a culture of community, sportsmanship, and leadership. In this 2019 photograph, members of the Mount Paran team participate in an annual dance supporting a senior citizen community center. Jake Williams (left) and Andrew Bennet (second from left) cut a move at Walton Properties. Williams and Bennet both lettered in baseball, basketball, and football. Bennet signed with Sanford University to play baseball. (Courtesy of Mount Paran Christian School.)

HARRISON HIGH SCHOOL

1992 – PRESENT

Harrison High School can boast the most successful and consistent baseball program in the Kennesaw area. Since their first season in 1992, the Hoyas have won two state championships (1998 and 2010), captured four Georgia Dugout tournament championships (1995, 1996, 2003, and 2008), dominated in six regional championships (1996, 1997, 1998, 2008, 2015, and 2019), and made 21 playoff appearances with six advancements to the state quarterfinals. Harrison teams were twice given national rankings by *USA Today*: 15th in the nation in 2010 and 25th in 1998. The Atlanta Braves 400 Club named Mic Knox and Corey Patterson Player of the Year in 1997 and 1998, respectively, and Ben Sutter Pitcher of the Year in 1998. Harrison takes great pride in taking care of its baseball fields and has been recognized as the High School Field of the Year by the Georgia Dugout Club in 2002 and 2014. From 1995 to 2019, the team sent 117 players to play at the college level, and 17 have been drafted into professional baseball, including Adam Everett and the Patterson brothers, Corey and Eric. To date, Everett has been the most prolific baseball player produced by Harrison and the Kennesaw baseball system. He played for North Carolina State University and then the University of South Carolina, won a gold medal in baseball in the 2000 Olympics in Sydney, Australia, played major-league baseball from 2001 to 2011, was crowned a champion with the Houston Astros in the 2005 World Series, served as an infield instructor and bench coach for the Astros, and finally became a minor-league coach for the Atlanta Braves in 2019. Everett maintained his relationship with Harrison High School's baseball program throughout his career and was quoted in 2009 as saying, "Coach Elkins has been hitting me grounders for 16 years. That's how I stay sharp in the offseason. I go back to the high school before practices and take grounders from coach Elkins about 30 minutes a day." With a campus and baseball field across the street from where Preacher Clackum built his storied baseball program, the very fields where a young Adam Everett would develop as a player, Harrison High School has forged an outstanding baseball program that would make Preacher proud.

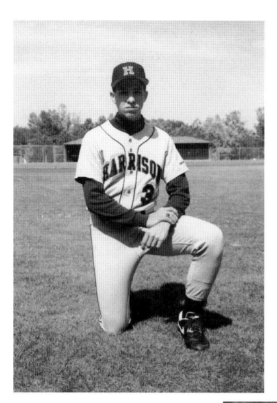

Matt Bridges poses for a photograph in 1993. Bridges played at North Cobb High School in 1991 and moved to Harrison when it opened in 1992. He played for Harrison from 1992 to 1994 as a starting pitcher and then primarily pitched as a reliever. Bridges won the first Pitcher of the Year award at Harrison and is still ranked in the school's top 10 for season and career ERA. (Courtesy of the Bridges family.)

Adam Everett turns a double play during a 1994 regular season game. As of 2020, Everett still holds six records in the Harrison top 10 for batting statistics, including second and third most runs in a season. During the 1994 and 1995 seasons, he batted .423 and .425 respectively. Everett was named to the All-County team and played for the Georgia Dugout Club All-Star team in 1995. Drafted by the Chicago Cubs in 1995, he made his major-league debut for the Detroit Tigers on August 30, 2001, and played professionally until 2011. Harrison retired his jersey (No. 1) in 2001. (Courtesy of Harrison High School.)

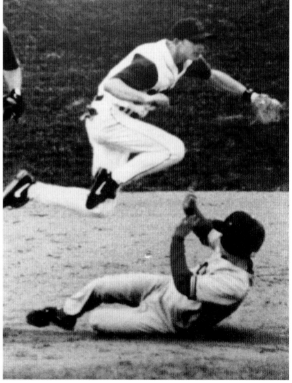

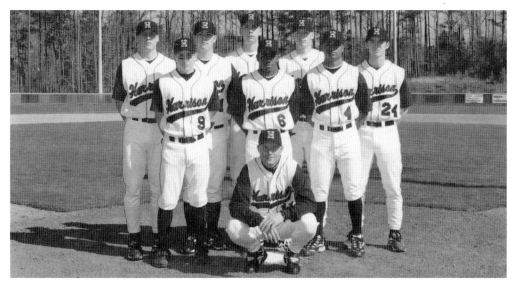

Players pose around the 1998 season. In front is coach Mike Power, who led his team to its first state championship that year. From left to right are (first row) Josh Manner, Ben Foster, and Corey Patterson; (second row) John Swanson, Ben Sutter, Justin Rowland, Ben Hudson, and Britt Thompson. Patterson was the first Hoya to break into the major leagues after being drafted by the Cubs in the first round in 1998 (he was the third overall pick). He played in the major leagues from 2000 to 2011 with the Cubs, Baltimore Orioles, Cincinnati Reds, Washington Nationals, Milwaukee Brewers, Toronto Blue Jays, and St. Louis Cardinals. His No. 4 jersey was retired by the Hoyas in recognition of his legacy. (Courtesy of Harrison High School.)

Ben Sutter pitches in the 1998 state semifinals against the Colquitt County Packers. Harrison swept Colquitt and moved on to the state championship. As of 2020, Sutter still owns the number-one spot in Harrison team history for single-season wins (14), single-season games pitched (20), single-season innings pitched (102), single-season strike outs (97), career wins (33), games pitched (53), and career innings pitched (248.1). (Courtesy of Harrison High School.)

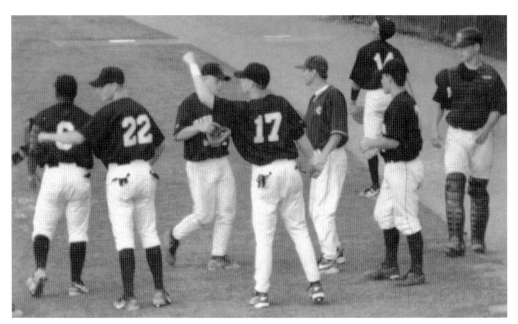

The team prepares for the 1998 Georgia state championship game against Sprayberry High School. From left to right are Ben Foster, John Fritchman, Sean O'Donnell, Mike Rimbey, Steven Ford, unidentified, Scott Creel, and Ben Hudson. (Courtesy of Harrison High School.)

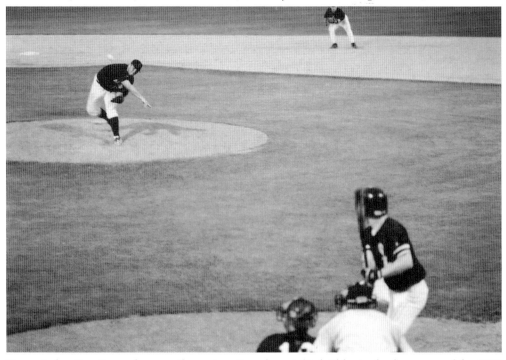

Hoya pitcher Ben Sutter fires a strike against Sprayberry's Rick Elder in the first game of the 1998 state championship. At second base is Scott Creel, and the catcher is Ben Hudson. Harrison won this game 3-0 and the second game of the double header 10-9. (Courtesy of Harrison High School.)

Players celebrate after winning the 1998 Georgia state championship. From left to right are John Swanson, Kerry Shouldeen, Ben Foster, and Brad Kirkland. (Courtesy of Harrison High School.)

The team receives the 1998 state championship after sweeping Sprayberry High School. At the left with the microphone is Harrison High School's principal, Dexter Mills. Identifiable players are, from left to right, Ben Hudson, Scott Creel, John Fritchman, Stephen Ford, Justin Rowland, Robert Perry, and Corey Patterson. (Courtesy of Harrison High School.)

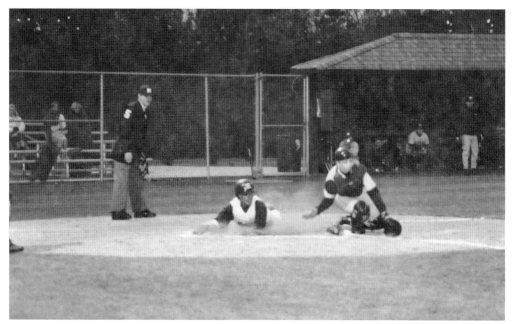

Brandon Smith makes a head-first slide to score against Wheeler High School in a 1999 game. Smith hit 13 doubles in a season, which as of 2020 remains tied for fourth in school history. (Courtesy of Harrison High School.)

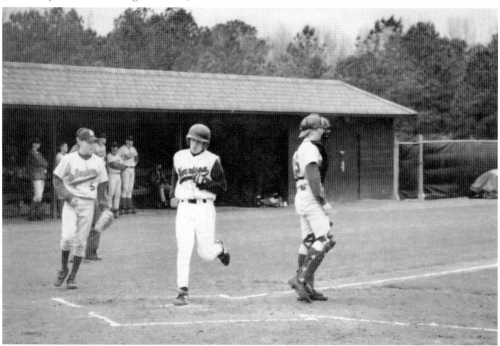

Harrison player Jon Wade scores against rival McEachern High School in the 1999 regional championship game. Wade went on to play for Virginia Military Institute. (Courtesy of Harrison High School.)

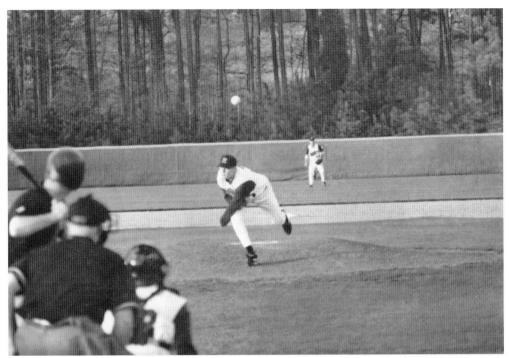

Harrison pitcher Brannon Sikes delivers a changeup in a 1999 junior varsity game with Blake Bailey in the background at center field. Sikes pitched for the University of North Georgia, and Bailey played for Tusculum College. (Courtesy of Harrison High School.)

Catcher Jonathan Douillard prepares to take the field from the dugout during the 2000 season. During Douillard's time at Harrison, he set seven top-10 batting records that still stand as of 2020. A versatile athlete, Douillard played catcher, third baseman, and relief pitcher. He went on to play at Vanderbilt University and was drafted by the Chicago Cubs, playing in their minor-league system from 2004 to 2005. (Courtesy of Harrison High School.)

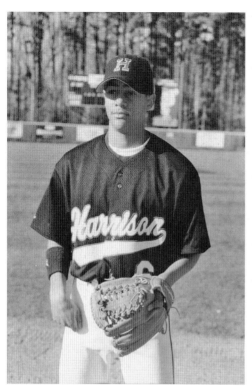

Eric Patterson poses for a pregame photograph in 2001. While at Harrison, Patterson set eight top-10 batting records that still stand as of 2020. He went on to play at Georgia Tech and later was drafted by the Chicago Cubs. He play in the major leagues from 2007 to 2011 for the Cubs, Blue Jays, Athletics, Red Sox, and Padres. (Courtesy of Harrison High School.)

Coach Mark Elkins celebrates the signing of two of his players to college baseball contracts in November 2011: Matt Gonzalez (left) and Zack Bowers. Gonzalez played for Georgia Tech and Bowers for the University of Georgia. (Courtesy of Harrison High School.)

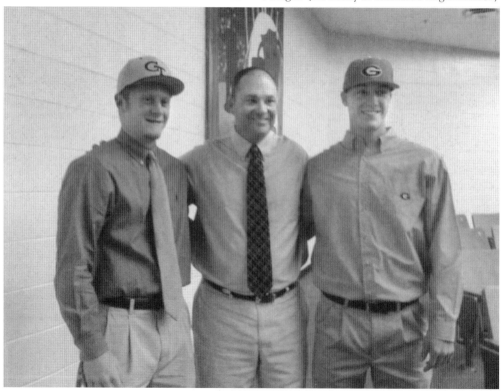

Coach Mark Elkins talks to 75 summer camp players in the summer of 2014. The camp raises money for the team's booster club supporting the upcoming season and also serves as an opportunity to scout growing talent in the Kennesaw area. (Courtesy of Harrison High School.)

Coach Elkins summons his son, reliever Tyler Elkins, in a 2015 game against North Paulding in the regional championship. Harrison beat North Paulding in this game and won the regional title the next day. Baseball creates bonds between fathers and sons that are deep and meaningful. Tyler went on to play for Georgia Gwinnett College. (Courtesy of Harrison High School.)

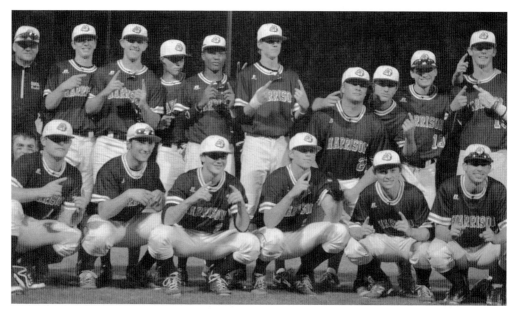

Players celebrate a victory against North Paulding that secured the regional championship in April 2015. From left to right are (first row) James Williams, Ross Neely, Haeden Messina, Harrison Corley, Aiden Loucks, Andrew Burchell, and Jacob Jones; (second row) coach Mark Elkins, Ben Brock, Jacob Rogers, Jake Shelby, Jayson Cook, Tyler Elkins, C.J. Turner, Sam Kuchinski, Ben Brock, and Cole Austin. (Courtesy of Harrison High School.)

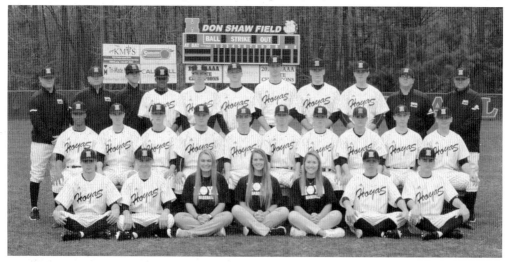

The Harrison Hoyas pose for a 2019 team photograph. From left to right are (first row) Cooper Guilotte, Nick Brunswick, Casie Paris, Sabrina Pestana Aguiar, Mallori Nesbit, Justin Wobb, and Dylan Hughes; (second row) Micah Davis, Evan Dory, Bowen Mitchell, Mitchell Walker, Fisher Keith, Camden McNearney, Andrew Scott, Nick Goetz, Collin Caldwell, and Conner Todaro; (third row) coach Matt Gonzalez, coach Jason Evans, coach Chris Widing, Brian Drakeford, Bryce Clark, Zach Elmy, Dylan Brown, Charlie Tull, Baylor Akin, coach Jake Storey, and coach Mark Elkins. (Courtesy of Harrison High School.)

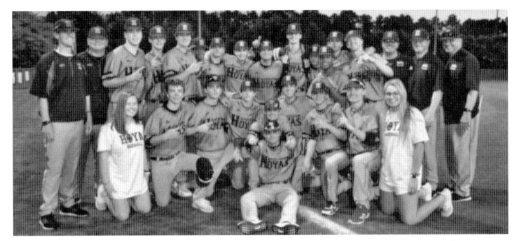

Harrison players take a celebratory photograph after winning the regional championship against South Cobb in April 2019. From left to right are (first row) Caroline Cunningham, Justin Wobb, Dylan Hughes, Andrew Scott, Nick Goetz, Cooper Guilotte, Evan Dory, Camden McNearney, Nick Brunswick, and Casie Paris; (second row) coach Chris Widing, coach Jason Evans, Charlie Tull, Bowen Mitchell, Baylor Akin, Brian Drakeford, Conner Todaro, Collin Caldwell, Mitchell Walker, Dylan Brown, Andrew Scott, Micah Davis, Bryce Clark, Zach Elmy, coach Jake Storey, coach Matt Gonzalez, and head coach Mark Elkins. (Courtesy of Harrison High School.)

The team celebrates beating Houston County in the 2019 state playoffs. Players dogpile onto pinch hitter Brian Drakeford, who drove in Mitchell Walker to win game three in the state quarterfinals in May 2019. Cooper Guilotte is in the center with both arms up as Andrew Scott vaults onto another player with his arm up. (Courtesy of Harrison High School.)

BASEBALL IN KENNESAW

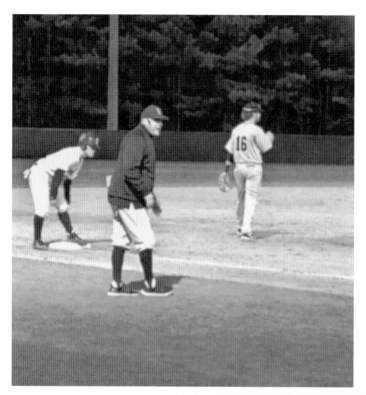

Coach Elkins encourages his batter as Harrison runners threaten during a February 28, 2020, home game against Rockmart. The Hoyas finished the 2020 season 10-5 with the cancellation of school and sports activities due to the coronavirus pandemic. As of 2020, Coach Elkins has led his team in 21 seasons, has won 425 games, and has secured three regional championships (5-AAAAA in 2008, 5-AAAAAA in 2015, and 6-AAAAAA in 2019). (Photograph by Shannon Caudill.)

Senior Brian Drakeford bats and senior Mitchell Walker waits on deck with runners on the corners in a 10-0 win over Rockmart on February 28, 2020. Drakeford has agreed to play for Tusculum University, while Walker has signed to play for Georgia Highlands College. The win over Rockmart was the start of a seven-game winning streak that was cut short due to the cancellation of games due to the coronavirus crisis. Harrison's last day of 2020 baseball took place on March 12 with a double-header sweep of Osborne, 16-0 and 10-0. (Photograph by Shannon Caudill.)

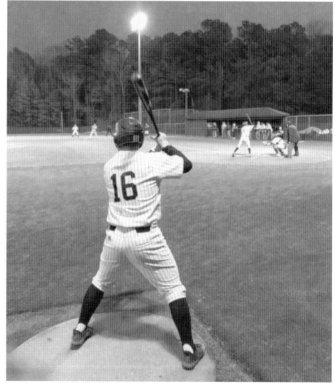

KENNESAW MOUNTAIN HIGH SCHOOL

2001–PRESENT

Kennesaw Mountain High School is the youngest of the local programs. Coach George Hansen has built the program from the ground up and put the school on the baseball map very quickly. Hansen's team won the Region 5-AAAAA championship in 2005, 2006, 2007, 2014, and 2015 and finished as the Class 5-A state runner-up in 2005, less than five years after the start of the program. Kennesaw Mountain has made three trips to the state semifinals and three quarterfinal appearances. Hansen's 2007 team was ranked fourth nationally by *USA Today*. On March 28, 2019, Hansen celebrated his 400th win in a 3-2 victory over McEachern. Hansen has been recognized as an excellent coach through his induction to the Georgia Dugout Club Hall of Fame. He has achieved an impressive career record of 419-228 and was recognized as the 2005 State of Georgia Coach of the Year. His 2014 team was ranked by *Perfect Game* as third in the nation after defeating national champion Lambert High School 2-0, and the team also finished as the 2014 Perfect Game National Championship Tournament runner-up. In Kennesaw Mountain's short history, it has produced 68 players who have gone on to play at the college level. Kennesaw Mountain has produced notable major-league baseball draftees like Tyler Stephenson, Ryley Gilliam, and Reggie Pruitt.

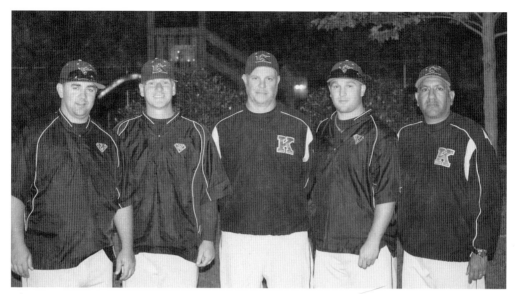

The 2011 varsity coaching staff poses after a regular season game. From left to right are Eric Blair (later Kennesaw Mountain head basketball coach), Brian Nelson (founder of Nelson Baseball School and later Dominion Christian School baseball head coach), head coach George Hansen, Jake Barrow (former Kennesaw High School player and college all-star), and Rich Oria (2019 High School Assistant Coach of the Year). (Courtesy of the LoCurto family.)

Tyler Stephenson gets into the action as a catcher during his freshman year in 2012 with pitcher Joe Marlow, then a senior. Marlow went on to pitch for the University of South Carolina. (Courtesy of the Stephenson family.)

Chase Slone (left) and Tyler Stephenson take a moment to pose with coach George Hansen in 2014. Slone would later pitch for Augusta University. (Courtesy of the Stephenson family.)

Junior Tyler Stephenson plays catcher during a 2014 game. That year, Kennesaw Mountain played at the Gwinnett Cool Ray Stadium. As Tyler's mom, Rhonda Stephenson, recalls, "Tyler had a 'moment' that went viral his senior year when he played against Milton in play-off double-header games. The first game, he hit a home run. After that, his next three at bats were intentional walks. During the second game, after they finally had to pitch to him, he hit another home run and did a bat flip. While this is certainly not Tyler's character, it was a playoff game and when he finally got a chance to hit, well he got caught up in the moment. His first and only bat flip during his career. We had scouts tell us that he had every right to do it as they wouldn't pitch to him." (Courtesy of the Stephenson family.)

It is college signing day for six Kennesaw Mountain High School players in 2015. From left to right are Zach Goodman (Clemson), Tyler Stephenson (Georgia Tech), Reggie Pruitt (Vanderbilt), Ryley Gilliam (Clemson), Cole Buffington (The Citadel), and Colin LoCurto (Georgia College). Stephenson was recognized as the 2015 Metro-Atlanta High School Player of the Year and signed to play for Georgia Tech but was later drafted by the Cincinnati Reds as the 11th pick in the 2015 Major League Baseball first-year player draft. (Courtesy of the Stephenson family.)

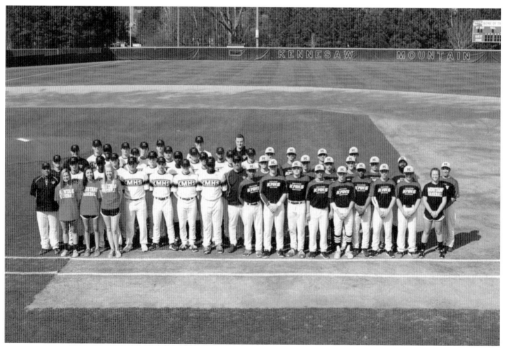

The varsity and junior varsity teams pose in 2015. The 2015 varsity team was led by excellent pitching from Matt Cole, Daniel Dolinsky, and Patrick Martin. (Courtesy of the LoCurto family.)

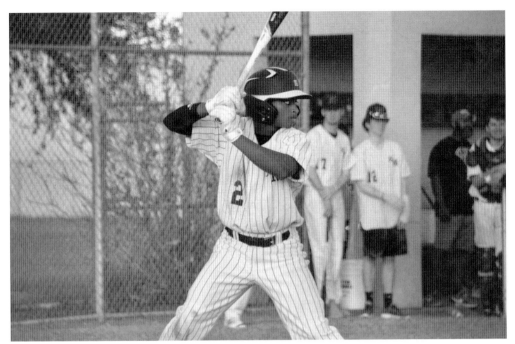

Shortstop Savon Battle bats during a 2018 game. He later played in the 2018 Diamondback Invitational in Las Vegas, Nevada. (Courtesy of the Whaley family.)

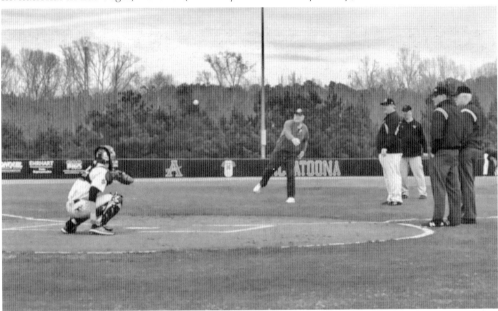

George Michael "Pops" Hansen throws out the first pitch at the annual "Battle of the Brothers" game pitting his sons' teams against one another. To the right of Pops stand his two sons, George Hansen (left) coaching Kennesaw Mountain High School and Keith Hansen coaching rival Allatoona High School. In this 2017 game, Allatoona came out ahead with a 6-2 victory. (Courtesy of the Whaley family.)

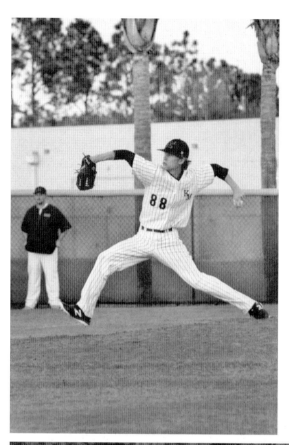

Kennesaw Mountain pitcher Dylan Williams delivers a strike against Freedom High School in Orlando, Florida, on February 24, 2018. Williams went on to play for Young Harris College. (Courtesy of the Whaley family.)

Mustang center fielder Will Fincher throws the ball in after making a catch in a 2019 game. Kennesaw Mountain had a second-round finish in the 7-A Georgia state playoffs that year. (Courtesy of the Whaley family.)

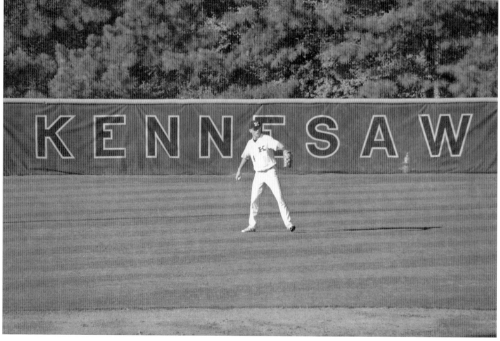

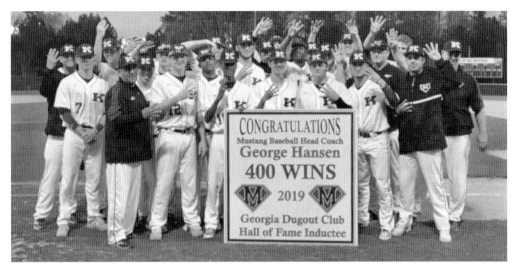

The Mustangs celebrate George Hansen's 400th win as the head coach of Kennesaw Mountain High School in a March 28, 2019, win over McEachern. From left to right are assistant coach Matt Graeff, Reece Schwickerath, Taylor Lumpkin, assistant coach Rich Oria, Will Fincher, Luke Darwiche, Brady Schwickerath, John Armstrong, Justin Barnes, Luke Staggs, Logan Jackson, Jarrett Guest, Dylan Williams, Will McCrum, Ryne Oria, Tyler Sylvester, Bryce Tincher, Sam Sparks, Gavin Scaggs, C.J. Whaley, Jonathan Douglas, assistant coach Phillip Nasworthy, Grant Moody, Eric DeJesus, and head coach George Hansen. (Courtesy of the Whaley family.)

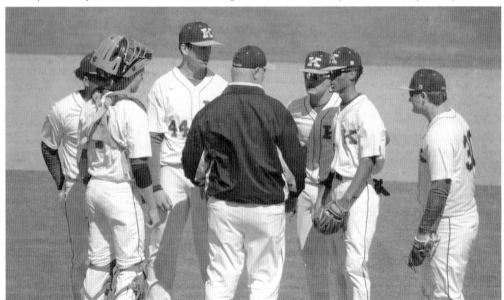

Coach George Hansen huddles on the mound during a game against Woodland High School in 2020. This was one of only three home games that Kennesaw Mountain got to play during the coronavirus-shortened season. From left to right are Dhruva Narine, Reece Schwickerath, C.J. Whaley, head coach George Hansen, Eliud Poventud, Logan Jackson, and Sam Sparks. (Courtesy of the Whaley family.)

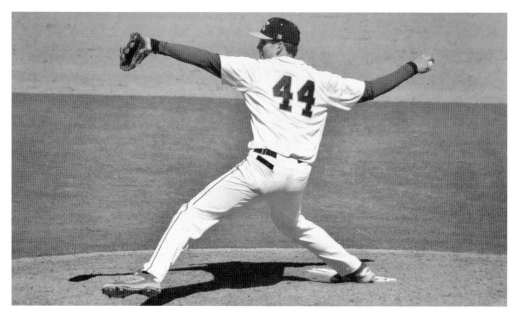

C.J. Whaley pitches against the Sprayberry High School Yellow Jackets on February 29, 2020, helping Kennesaw Mountain win 11-5. Whaley, a junior, played first base and pitched for the Mustangs during the 2020 season. (Courtesy of the Whaley family.)

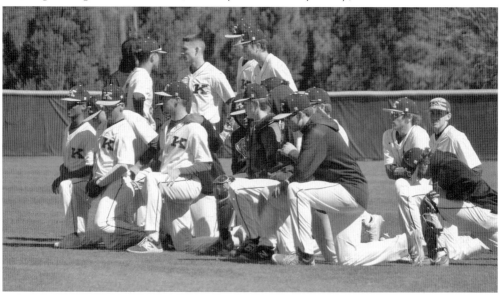

The Kennesaw High School Mustangs await Coach Hansen's postgame victory huddle after a March 2020 game. From left to right are Logan Jackson, Brady Schwickerath, Nick Finkbiner, Jonathan Douglas, Eliud Poventud, Tyler Sylvester, Luke Staggs, Reece Schwickerath, Will Fincher, Michael Hill, Dylan Dietz, Ethan Snipes, Dhruva Narine, Ryne Oria, C.J. Whaley, Sam Sparks, Mitch Jaquich, Nick Daniel, and Bradley Smith. Due to the coronavirus pandemic, the team's last game of 2020 was played on March 11. The Mustangs finished their shortened season with a record of 7-7. (Courtesy of the Whaley family.)

WEST COBB

HIGH-LEVEL TALENT AND THE BUSINESS OF BASEBALL

In a 2018 *Atlanta Journal-Constitution* interview, Harvey Cochran, director of the Georgia Dugout Club, shared observations about baseball in Georgia and Cobb County: "These kids in Georgia high school baseball can do things they couldn't do 30 years ago. Scouts tell me it's the third-most recruited state in the country now behind Texas and California and right there with Florida." Cochran believes the 1983 East Marietta team that won the national Little League World Series was the spark that ignited the larger interest in baseball in the area. "That's when the game suddenly got noticed," he theorized. Cobb County can boast a vibrant, nationally recognized baseball culture. In 2019, a *Marietta Daily Journal* article proclaimed "Cobb County Producing Pro Baseball Players" and provided a list of 29 current major-league players, 11 of whom had Kennesaw roots detailed in this book. In 2017, the Braves moved to SunTrust Park (renamed Truist Park in 2020) north of the city in Cobb County to be part of an energetic baseball culture and be near a larger block of their fan base, which was mapped out by ticket sales in a 2013 *Washington Post* article entitled "Why the Braves Are Leaving Atlanta, in One Map." The 2019 season attendance was roughly 2.65 million, the highest it had been in 12 years, with revenues up an impressive 69 percent compared to the Braves' final season at Turner Field in 2016. In addition to the baseball programs mentioned in earlier chapters, the West Cobb Baseball Association boasts an impressive program for players ages 13–18 and plays out of Big Shanty Park in Kennesaw. North Cobb Christian School has established an impressive program in its own right with one national championship, two state championships, and some of the best facilities and fields in the region. In 2017, both D-BAT and the Titans Sports Academy built facilities in Kennesaw to provide services to meet the growing demand for youth baseball expertise and professional training. Kennesaw baseball talent has access to hundreds of excellent coaches who provide private lessons through organizations like D-BAT, Titans Sports Academy, East Cobb Baseball, 6-4-3 DP Athletics, Fowlkes Baseball, C-bat/Perfect Swing Tools, and many others in the area. Kennesaw and the Cobb County area will no doubt continue this tradition of baseball excellence, competition, and business investment.

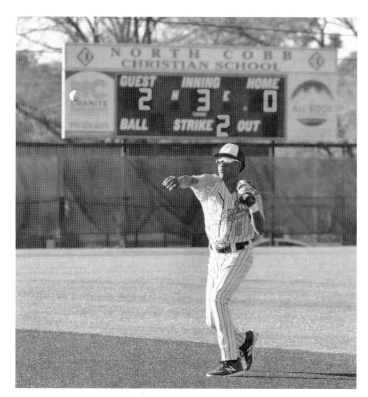

North Cobb Christian's Jason Walk warms up between innings in a March 6, 2020, game against Mount Paran. Unfortunately, the baseball season ended days later due to the coronavirus pandemic. North Cobb Christian School was on a roll in 2020 and finished 7-3 with a 5-1 record against regional rivals. (Courtesy of Beth Clark.)

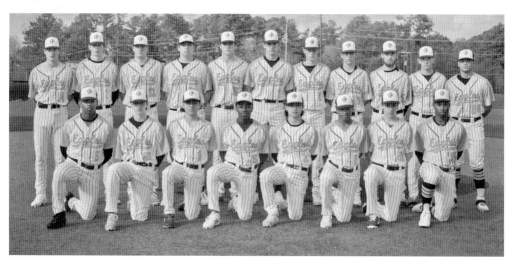

Members of the 2020 North Cobb Christian School team pose for a season photograph. From left to right are (first row) Ryan Pruitt, Ryan Cooper, Gustavo Melgar, Dallas Deas, Mattheson Go, Jason Walk, Hoke Phillips, and Maurice Gomez; (second row) Aidan Moza, Luke Brock, Riley Clingman, Zach Hamby, Jarrett Hanley, Lukas Farris, Elijah Bleu Johnston, Blake Dean, Austin Clark, Colin Innes, and Fernando Gonzalez. North Cobb Christian School has an excellent baseball program, winning the National Association of Christian Athletes national championship in 2008 and state championships in 2002 and 2006. (Courtesy of the Pruitt family.)

North Cobb Christian School's first baseman, Austin Clark, gets ready for the pitch in a 2020 regional game against Christian Heritage. Elijah Bleu Johnston is at second base, and Maurice Gomez is playing center field. Clark also played for 6-4-3 DP Athletics' 18-year-old travel team and will play for Covenant College after graduation. (Courtesy of Beth Clark.)

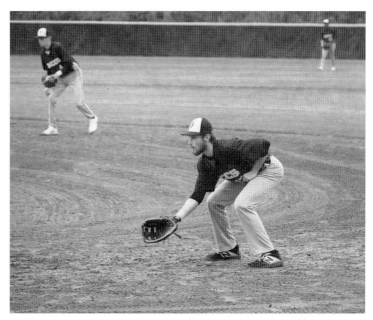

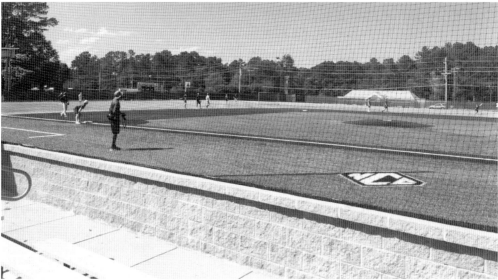

The 2019 annual Cobb–Gwinnett County All-Star Game gets in a workout at North Cobb Christian School. Team Cobb, coached by Keith Brown and assisted by Allatoona's Keith Hansen and North Cobb's Tom Callahan, defeated Gwinnett in a 9-6 battle at Hillgrove High School on June 4, 2019. From left to right are Adam Love (left field, Lassiter), Brett Blomquist (third base, Allatoona), C.J. Whaley (left field, Kennesaw Mountain), Trace Cate (third base, Hillgrove), the NeXup photographer, Saivion Mohammed (shortstop, McEachern), Gino Groover (shortstop, the Walker School), Logan McGuire (shortstop, Allatoona), Micaiah Williams (center field, Walton), Will Fincher (center field, Kennesaw Mountain), Wilbert Espinal (second base, South Cobb), Jack Gilsenan (second base, Hillgrove), Davis Hodges (right field, the Walker School). (Courtesy of the Whaley family.)

West Cobb's Jordan Wilmert slides into home for the win in a 2010 game at Big Shanty Park. Wilmert went on to play for Allatoona High School, graduating in 2014. Taking advantage of all the strong baseball programs in the area, he played Little League and travel ball at Acworth, Oregon Park, Adams Park, and Big Shanty (West Cobb Baseball Association). (Courtesy of the Wilmert family.)

C.J. Whaley delivers a strike for West Cobb Next LVL 15-year-old Red in a complete-game, two-hit shutout at Kennesaw Mountain High School over eXposure Baseball on June 4, 2018. Playing out of Big Shanty Park, Whaley's team defeated eXposure 8-0 and finished the summer season with a record of 20-9-2. (Courtesy of the Whaley family.)

A local player takes a batting lesson at D-BAT while softball players exercise in the background. The West Cobb D-BAT opened on February 17, 2017, and quickly became a staple of baseball and softball training in the area. At 34,000 square feet and boasting 26 batting cages, Kennesaw's D-BAT provides over 1,200 hours of lessons per month and boasts the highest number of members among more than 100 D-BAT facilities worldwide as of 2019. (Courtesy of Rush Eskridge.)

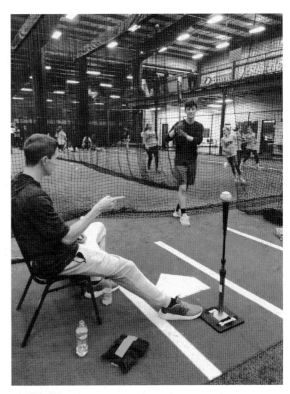

Local high school players attend a fall 2019 skills camp taking advantage of the D-BAT indoor field. D-BAT supports local baseball in many ways. For instance, it donates space for Adams Park tryouts during inclement weather and end-of-season team parties. In 2020, Kennesaw's D-BAT was used by Atlanta Braves players for batting practice during the coronavirus pandemic. (Courtesy of Shannon Caudill.)

The Titans Sports Academy started as an offshoot of East Cobb Baseball in Marietta in 2003. In 2013, the Titans Sports Academy formally broke off from East Cobb Baseball and eventually settled in Kennesaw with the opening of a new facility in 2017. The Kennesaw complex includes 16,000 square feet of athletic training space with eight batting cages that are 70 feet long and an exterior baseball field. (Courtesy of Titans Sports Academy.)

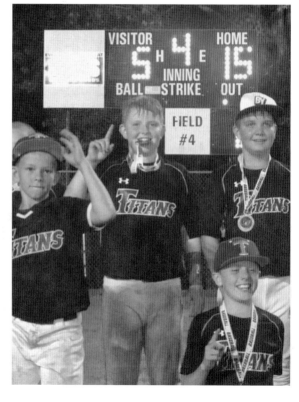

Titans Sports Academy players celebrate a championship at the October 2019 Southern Sports Fall Invitational. From left to right are Aaron Eison, Brody Wilkes, Robert Turner, and Braxton Stegall. (Courtesy of the Wilkes family.)

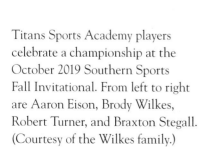

Coach T.J. Pagan from 6-4-3 DP Athletics provides a hitting and pitching lesson to a player at Adams Park. Pagan is an example of the talented and experienced coaching available to players in the area. A former pitcher for the University of Pittsburgh, Pagan coaches 12- and 17-year-old travel ball teams. Started in 2007 by coach Danny Pralgo, 6-4-3 DP Athletics hosts teams aged 8–18 out of Aviation Sports Complex in Marietta. According to Perfect Game, 6-4-3 DP Athletics has produced 508 college baseball player commitments, with 30 players drafted by major league baseball, in just 13 years of operation. (Photograph by Shannon Caudill.)

Jimmy Fowlkes instructs a student on proper batting technique at Adams Field in Kennesaw. Fowlkes is the founder of the nonprofit Kennesaw-based Fowlkes Baseball. He is a former high school coach, instructional camp director, and private instructor. Fowlkes can also be found coaching his youngest son, Jacob, in Adams Park recreational baseball games. (Courtesy of the Fowlkes family.)

Craig Hawkins, owner of Perfect Swing Tools and C-bat, provides bat swing analysis and instruction to a player at his Kennesaw facility. Hawkins, a former high school coach, provides specialized batting instruction and has invented equipment that helps players improve their swing. He has provided batting lessons to 12 players who were later drafted by major-league teams, and provided batting instruction to one Atlanta Braves player during the coronavirus pandemic. He has partnered with local Adams Park all-star and travel ball teams to produce several state championships, major tournament victories, and national rankings for Kennesaw teams and also provided lessons to a number of softball players who signed with college teams. (Photograph by Shannon Caudill.)

The 2017 season was the Atlanta Braves' first in SunTrust Park, which was renamed Truist Park in 2020, and the Braves have reached the playoffs in 2018 and 2019 to the delight of baseball fans and aspiring players. Pictured here is Kennesaw's own, Braves shortstop Dansby Swanson, the inspiration for many young baseball players. Kennesaw teams participate in a number of competitions and events that allow them to parade around the warning track before Braves games each year, or actually play on the field in the case of some high school and college games. (Photograph by Shannon Caudill.)

10

LOVE OF THE GAME

FROM PREACHER TO DANSBY

Joy is watching young baseball players develop as competitors and people. In the movie *Field of Dreams*, the character Terence Mann (played by James Earl Jones) delivers a monologue about the importance of baseball to the history of America that still resonates today:

> The one constant through all the years, Ray, has been baseball. America has rolled by like an army of steamrollers. It's been erased like a blackboard, rebuilt, and erased again. But baseball has marked the time. This field, this game—it's a part of our past, Ray. It reminds us of all that once was good, and it could be again.

Kennesaw can boast its own "Field of Dreams" with Preacher Clackum's home-built field that raised several generations on local baseball. Kennesaw and the surrounding communities have a baseball culture and legacy worth celebrating. This book does its part in capturing and preserving that past. Challenges like wars, depressions, and even pandemics cannot stop the rolling history and love of this game. Baseball is a memory maker—the smell of the freshly cut grass . . . the smile of kids after a big win . . . the time parents spend with their children—there is goodness in all of it. The vast majority of kids won't make it to the big leagues, but everyone who has ever played the sport holds on to the daydream of stepping up to the plate in the World Series. Every crack of the bat, strike thrown, or well-executed fielding play gives children the gift of those special moments where they felt like they are major-league players. Some highlighted in this book have lived that dream, which only makes it more real and meaningful because they did it with Kennesaw baseball roots.

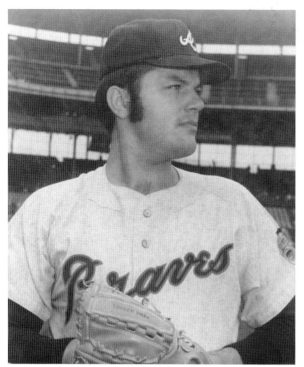

Jim Nash blazed a trail in Kennesaw baseball. He was a standout player at Clackum Field, played seven years in the big leagues, pitched for the Atlanta Braves in the early years of the club, and started the Kennesaw State University baseball program as its first head coach. Nash still participates in Braves Alumni and Braves Foundation events each year. (Courtesy of the Nash family.)

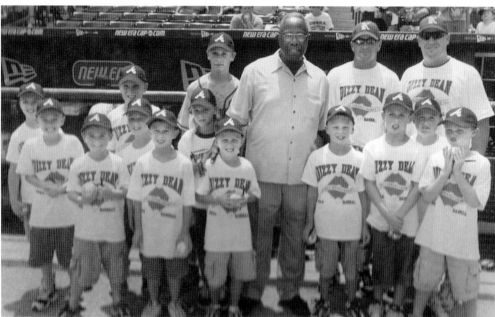

The seven-year-old Kennesaw Heat All-Star team Dizzy Dean World Series champions pose with Hall-of-Famer Hank Aaron at Turner Field around 2002. From left to right are Josh Loud, Justin Evans, Scotty Turner, Tyler Stephenson, Alec Krupp, Michael Atkinson, two unidentified, Hunter Clark, Aaron, Derek Krupp, coach Jeff Turner, Blake Swanson, coach Rusty O'Cain, Jordan O'Cain, and Joe Reich. (Courtesy of the Stephenson family.)

LOVE OF THE GAME

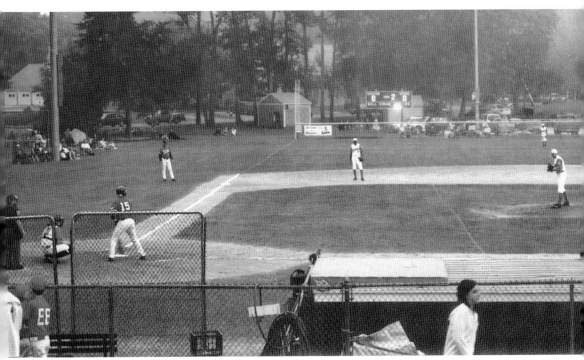

In this June 29, 2002, photograph, two former Harrison High School players face off against each other far from home in Cape Cod Baseball League action. Jon Douillard steps up to the plate as his friend and former teammate Brian Rogers prepares to pitch against him. Started in 1885, the Cape Cod Baseball League is considered the premier amateur and collegiate summer league in the nation and an annual showcase of baseball talent. Rogers went on to play minor-league baseball for the Pittsburgh Pirates from 2006 to 2007, and Douillard played minor-league ball for the Chicago Cubs from 2004 to 2005. (Courtesy of Harrison High School.)

Adam Everett slides safely into home in a 2005 Houston Astros home game against the St. Louis Cardinals in the year the Astros won the World Series. Dubbed "Mr. Smooth" by ESPN, Everett is the most successful and longest-playing professional baseball player to come out of Kennesaw-area programs and the only one to boast winning a World Series. In 2007, Astros third baseman Morgan Ensberg was quoted as saying, "I can say in my heart of hearts that he's the best defensive shortstop on the planet." Everett's 110 defensive runs saved are nearly three times more than any other Astros shortstop, and he still holds the Astros record for best defensive wins above replacement (13.8). (Courtesy of the Everett family.)

In this 2016 photograph, Dansby Swanson, Adams Park alumnus and Atlanta Braves shortstop, poses with two KBA players, Nicholas (left) and Thomas Caudill, at Turner Field prior to a September game. When told that the boys played at Adams Park, he responded with a big smile and said "My old stomping grounds!" (Courtesy of the Caudill family.)

LOVE OF THE GAME

On March 13, 2020, Major League Baseball decided to close spring training, delay the 2020 season, and encourage all players to go home. This photograph captures four 2015 Kennesaw Mountain High School players linking up for a garage workout before social distancing went into effect. Not knowing how long the coronavirus would limit the baseball season, players continued to work out to stay in peak condition. From left to right are Colin LoCurto, Zach Goodman, Tyler Stephenson, and Ryley Gilliam. Stephenson was invited to spring training with the Cincinnati Reds, playing in 12 games with 22 plate appearances and achieving a .375 batting average. Gilliam was invited to spring training by the New York Mets and was considered the team's 27th prospect, pitching for its AAA affiliate in Syracuse, New York. Baseball bonds make for strong friendships and, like old times, these four former teammates worked out in the garage of Tyler's parents' house. (Courtesy of the Stephenson family.)

Discover Thousands of Local History Books
Featuring Millions of Vintage Images

Arcadia Publishing, the leading local history publisher in the United States, is committed to making history accessible and meaningful through publishing books that celebrate and preserve the heritage of America's people and places.

Find more books like this at
www.arcadiapublishing.com

Search for your hometown history, your old stomping grounds, and even your favorite sports team.

Consistent with our mission to preserve history on a local level, this book was printed in South Carolina on American-made paper and manufactured entirely in the United States. Products carrying the accredited Forest Stewardship Council (FSC) label are printed on 100 percent FSC-certified paper.

MADE IN THE